W9-CKR-811

EXISTING LIGHT TECHNIQUES FOR
WEDDING AND PORTRAIT PHOTOGRAPHY

Bill Hurter

AMHERST MEDIA, INC. ■ BUFFALO, NY

About the Author

Bill Hurter started out in photography in 1972 in Washington, DC, where he was a news photographer. He even covered the political scene—including the Watergate hearings. After graduating with a BA in literature from American University in 1972, he completed training at the Brooks Institute of Photography in 1975. Going on to work at *Petersen's PhotoGraphic* magazine, he held practically every job except art director. He has been the owner of his own creative agency, shot stock, and worked assignments (including a year or so with the L.A. Dodgers). He has been directly involved in photography for the last thirty years and has seen the revolution in technology. In 1988, Bill was awarded an honorary Masters of Science degree from the Brooks Institute. He has written more than a dozen instructional books for professional photographers and is currently the editor of *Rangefinder* magazine.

Copyright © 2008 by Bill Hurter.
All rights reserved.

Front cover photograph by Jeffrey and Julia Woods.
Back cover photograph by Craig Kienast.

Published by:
Amherst Media, Inc.
P.O. Box 586
Buffalo, N.Y. 14226
Fax: 716-874-4508
www.AmherstMedia.com

Publisher: Craig Alesse
Senior Editor/Production Manager: Michelle Perkins
Assistant Editor: Barbara A. Lynch-Johnt

ISBN-13: 978-1-58428-228-0
Library of Congress Control Number: 2007942649
Printed in Korea.
10 9 8 7 6 5 4 3 2 1

No part of this publication may be reproduced, stored, or transmitted in any form or by any means, electronic, mechanical, photocopied, recorded or otherwise, without prior written consent from the publisher.

Notice of Disclaimer: The information contained in this book is based on the author's experience and opinions. The author and publisher will not be held liable for the use or misuse of the information in this book.

Table of Contents

PHOTOGRAPH BY PARKER PFISTER.

PHOTOGRAPH BY KEVIN JAIRAJ.

PHOTOGRAPH BY DENNIS ORCHARD.

PHOTOGRAPH BY SCOTT ROBERT LIM.

Introduction

So much has changed in the way we record our special moments today. Film used to be slow and required a lot of light to adequately capture a good portrait. The lighting was a direct imitation of the portrait lighting of the great masters, like Rembrandt and Sargent. In retrospect, however, that genre of formal portraiture reveals itself as merely an imitation of the great portrait artists' oils. It was not a duplicate style; it was—and still is—a totally different medium because of the realism of photography.

But with changing styles and attitudes, both portraiture and wedding photography became much less rigid. Today's portrait and wedding clients want to be recorded as themselves. They want fun, spontaneous images that depict them having a good time and living their life.

People want the times of their lives recorded with joy and spontaneity. Here, birds takes flight as if on cue. Photograph by Jennifer Baciocco.

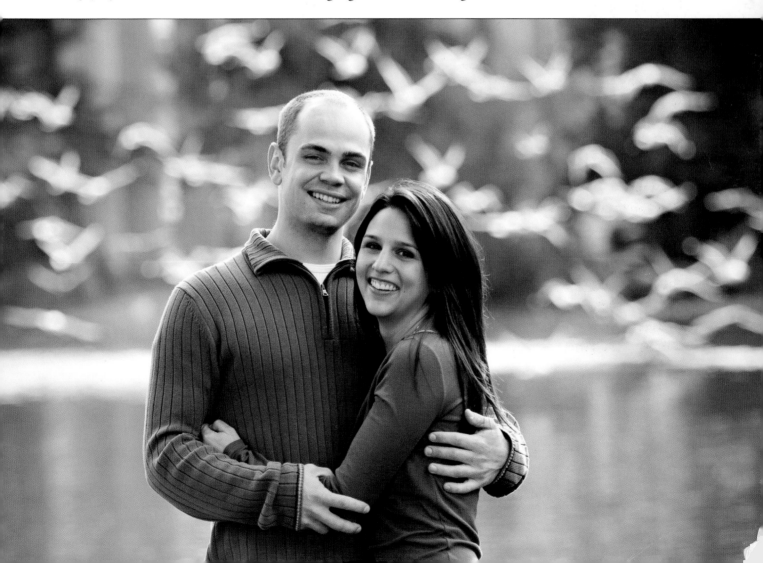

Great portrait opportunities present themselves regardless of the lighting. Here, Joe Buissink took so-so lighting and turned it into a classic portrait.

One consequence of these changing notions about portraiture is that the whole world has become the studio in which portrait and wedding photography is produced. Yet, while this presents an exciting array of creative options for photographers, it also presents significant challenges. Foremost among these is the need to work with light—redirecting, shaping, supplementing, and intensifying the existing light to perform as predictably as studio light did.

Fortunately, digital technology has made gaining a mastery of existing light easy and fun. With the ability to change ISO settings on the fly, the portrait and wedding photographer can quickly move from bright sunlight, to shade, to subdued indoor lighting. Digital capture also provides the ability to instantly preview images—so if you misjudged the lighting, you can re-take the shot immediately. The photographer and the subject or client can examine the captured images instantly and simultaneously, capitalizing on the excitement and instant feedback of the in-progress photo session.

The addition of vibration-reduction (VR) lenses to professional lens lines, like those from Canon and Nikon, has also extended the photographer's ability to shoot in light that may be beautiful but very dim. Similarly, the DSLR's ability to measure and control white balance is now so advanced that tricky color-balance situations, such as mixed lighting, can be handled with confidence.

*We are in the midst
of a true Renaissance in
professional photography . . .*

With increases in write-speed, buffer size, and the capacity of storage cards, photographers have also found shooting RAW files to be a practical option. Since virtually every aspect of image quality can be controlled from within the RAW file processor, it's easier than ever to perfect each shot. For those images that require a little more finessing, Lighting Effects (a miniature application within Photoshop) enables photographers to manipulate the light pattern and quality in an image—or even to introduce additional light sources.

As a result of all these advances, we are in the midst of a true Renaissance in professional photography—something we haven't seen since the affordable Canon AE-1 and Minolta Maxxum helped popularize 35mm SLR photography and spawned a huge number of professionals. Now, the same can be said for the growing number of new wedding and portrait photographers, inspired by similar digital marvels. It is an exciting time that will, no doubt, lead to further changes in how we record the lives and times of those special to us.

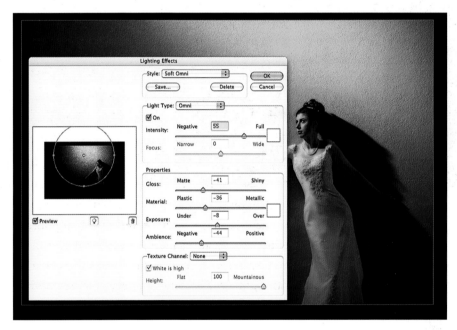

Photoshop's Lighting Effects filter at work on a Kevin Jairaj image.

1. The Nature of Light

Light is the photographer's brush. It is how the subject is rendered in a physical sense, but more importantly, it is a significant tool in how character is imparted in a portrait. As Bruce Dorn says in his Exploring Light DVD, "Photography is about light. The way light wraps a moment, the way it paints an emotion. Light shapes our perception and defines our world. Light creates the shadows that hide what needs to be hidden. Light reveals. Light illuminates."

This chapter is an introduction to light and its behavior. While it is not necessary to understand light like a physicist would understand it, knowing that light is energy and how that energy works is significant and useful when applying light photographically.

What Is Light?

Light is energy that travels in waves. Waves are a form of energy that usually move through a medium, like air or water. For example, imagine the ripples in a swimming pool after someone has jumped in. Is it the water that is moving or something else? Actually, the water in the pool stays pretty much stationary. Instead, it is the energy—the wave—caused by the person jumping into the pool that is moving.

Light waves are different than water waves, however, in that they don't require a medium through which to travel. In fact, light travels most efficiently in a vacuum; other elements, like air and water, actually slow light down. Light travels so fast in a vacuum (186,000 miles per second) that it is the fastest known phenomenon in the universe!

Light waves consist of both electric and magnetic energy. Like all forms of electromagnetic energy, the size of a light wave is measured in wavelengths, the distance between two corresponding points on successive waves. The wavelengths of visible light range from 400–700 nanometers (one millionth of a millimeter). The visible spectrum is, however, only a tiny section of the full range of the electromagnetic spectrum, which

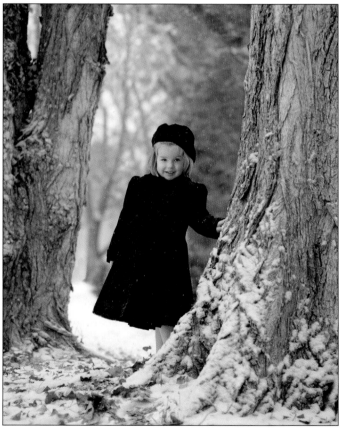

In this portrait by Drake Busath, the tone is high key (see page 33), but the subject dominates because of her dark hat and coat. Also, the young girl is positioned between two stately trees that create visual brackets. The effect is to rivet your attention on the subject; your eye never wanders.

LEFT—Light, which travels in waves, can be narrowed or widened or altered in a nearly infinite number of ways. Here, a very narrow beam of daylight is made to strike only the profile of the bride. The photographer, Yervant, made sure everything else went black, choosing to isolate just the edge of the bride's face.

RIGHT—People with eyeglasses can be very difficult to photograph because glasses both refract and reflect light. Mark Nixon handled the technical problem quite well, using soft umbrella light from the side so that the light would not create specular highlights on the glass. He also did some extensive dodging in Photoshop to remove small problems in the glass. Because eyeglasses are a medium that reduces the amount of light being reflected through them, the area around the eyes had to be dodged and adjusted for contrast and exposure to match the rest of the subject's face.

also includes radio, microwaves, infrared, ultraviolet, X-rays, and gamma rays—types of waves that are differentiated by their unique wavelengths.

Photons

Without delving into a lengthy description of physics, it is sufficient to say that photons are the raw material of light. When we see visible light, we are witnessing countless numbers of photons moving through space as electromagnetic waves. Photons are produced by light sources and reflected off objects. On an atomic level, light works like this: an atom of material has electrons orbiting its nucleus. Different materials have different numbers of electrons orbiting their individual atoms.

When atoms are excited or energized, usually by heat, for example, the orbiting electrons actually change to a different orbit and then gradually revert. This process emits photons, which are visible light having a specific wavelength or color. If there are enough photons and the frequency is within the visible spectrum, our eyes perceive the energy as light and we see. Any system that produces light, whether it's a household lamp or a firefly, does it by energizing atoms in some way.

The natural shade of late afternoon is very soft, but also lacks sparkle. To give the light a little extra snap, photographer J.B. Sallee fired an on-camera flash that was set to output at two stops less than the daylight.

The Behavior of Light

Unless it is traveling though a vacuum, the medium alters how light behaves. Four different things can happen to light waves when they hit a non-vacuum medium: they can be reflected or scattered; they can be absorbed (which usually results in the creation of heat but not light); they can be refracted (bent and passed through the material); or they can be transmitted with no effect. More than one of these results can happen simultaneously with the same medium, but what will happen is predictable. This is the key to understanding how lighting works in a photographic environment.

Reflection. One of the characteristics of light that is important to photography has to do with reflected light waves. When light hits a reflective surface at an angle (imagine sunlight hitting a mirror), the reflected wave will always come off the flat, reflective surface at the opposite angle at which the incoming wave of light struck it. In simple terms, the law can be restated as this: the angle of incidence is equal to the angle of reflection. Whether you are trying to eliminate the white glare of wet streets as seen through the viewfinder or to minimize a hot spot on the forehead of your bride, this simple rule will keep you pointed toward the source of the problem.

This simple rule will keep you pointed toward the source of the problem.

This rule also has applications in product and commercial photography. For example, when lighting a highly reflective object like silverware, knowing that the angle of incidence equals the angle of reflection tells you that direct illumination will not be the best solution. Instead, you should try to light the surface that will be reflected back onto the shiny object's surface.

Scattering. Scattering is reflection, but off a rough surface. Basically, because the surface is uneven, incoming light waves get reflected at many different angles. When a photographer uses a reflector, it is essentially to distort the light in this way, reflecting it unevenly (or, put another way, so that it diffuses the light).

Translucent surfaces, such as the rip-stop nylon used in photographic umbrellas and softboxes, transmit some of the light and scatter some of it. This

is why these diffusion-lighting devices are always less intense than raw, un-diffused light. Some of the energy of the light waves is being discarded by scattering, and the waves that are transmitted strike the subject at many different angles, which is the reason the light is seen as diffused.

Refraction. When light waves move from one medium to another, they may change both speed and direction. Moving from air to glass (to a denser medium), for example, causes light to slow down. Light waves that strike the glass at an angle will also change direction, otherwise known as refraction. Knowing the degree to which certain glass elements will bend light (known as the refractive index) allows optical engineers to design high-quality lenses, capable of focusing a high-resolution image onto a flat plane (the film or image sensor). In such complicated formulas, now almost exclusively designed by computers, the air surfaces between glass elements are just as important to the optical formula of the lens as the glass surfaces and their shapes.

In lighting devices, refraction is used with spotlights and spots with Fresnel lenses. These lenses, placed close to the light source, gather and focus the light into a condensed beam that is more intense and useful over a greater distance than an unfocused light of the same intensity. Spotlights are theatrical in nature, allowing the players on stage to be lit from above or the side by intense but distant lights, but they also have many applications in contemporary photography.

Absorption. When light is neither reflected nor transmitted through a medium, it is absorbed. Absorption usually results in the production of heat

Moving from air to glass (to a denser medium) causes light to slow down.

A dog's coat, especially a dog like this with a lot of wrinkles, absorbs most of the light that strikes it. The only area of the dog's face that efficiently reflects light is his eyes. The general rule of thumb with light-absorbing subjects is to give more exposure to the image if you want to record adequate detail in those areas. Photograph by Kersti Malvre.

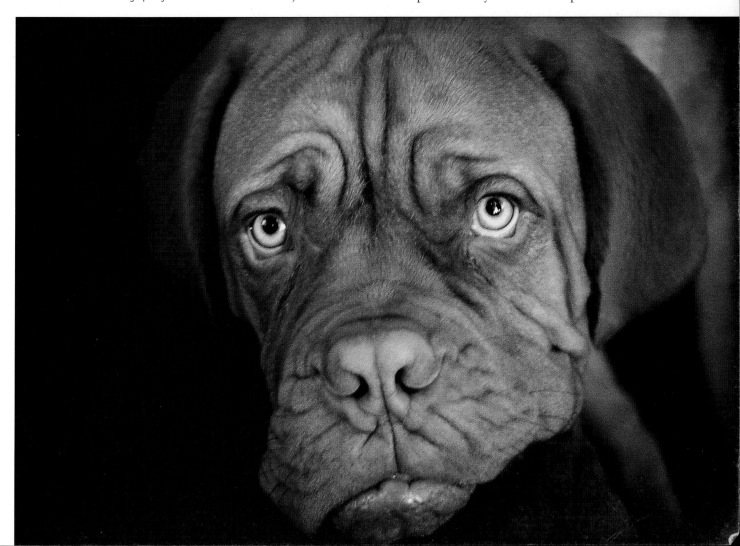

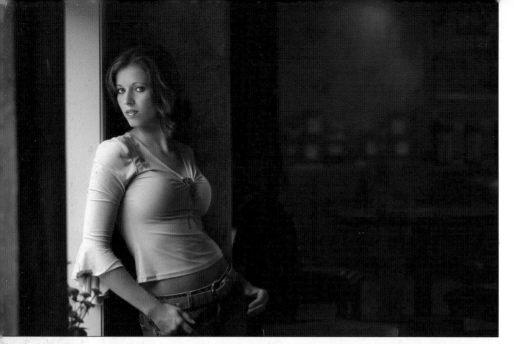

LEFT—Learning to see light takes patience. Read the main shadows to determine the direction and quality of the light. Read the catchlights (specular highlights) in the eyes and you can see the position of the light(s) relative to the person. Here Craig Kienast photographed his subject very close to a window to exploit the soft, directional light. The light falls off rapidly once it enters the large room. Note that light entering a portal, like a window or a doorway, follows the Inverse Square Law as if it were an artificial light source.

BELOW—The modern-day photographer can record a magnificent portrait in next to no light—and, in this case, in light with wildly varying color temperatures. Marcus Bell recorded the vicar "waiting for the bride" in the darkened vestibule of the church. The bride is invisible except for the little bit of her veil at which the vicar stares.

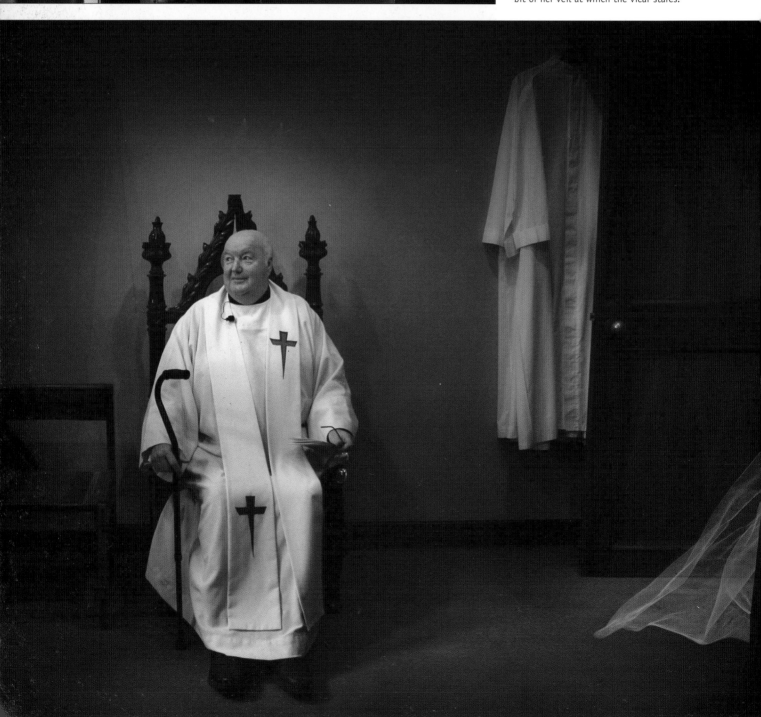

Marcus Bell likes fast lenses that he can shoot at maximum aperture and high ISOs to produce a miniscule band of sharpness. Here, only the eyes of 2006 Australian of the Year, Ian Frazier, are sharp. And not only are they sharp, but they contain a dash of cobalt blue in the midst of this monochrome portrait; another of the great advantages of digital is the ability to mix palettes within a single image.

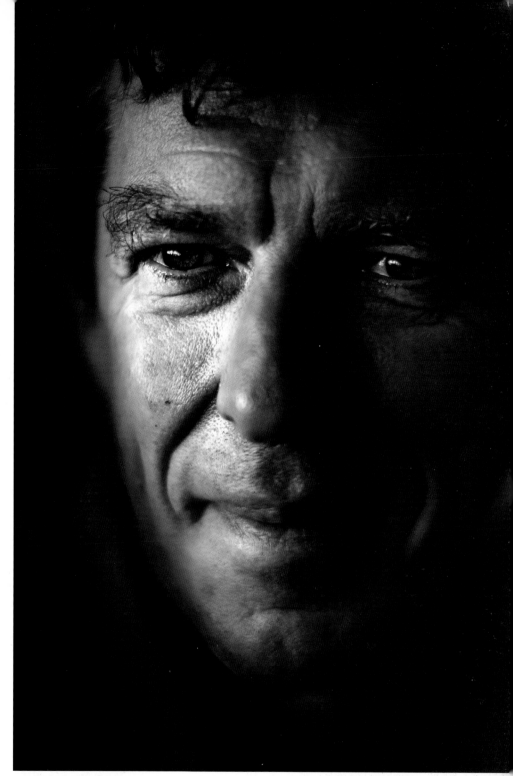

■ THE SUN AND LIGHT INTENSITY

The Inverse Square Law is true for all light sources but not particularly relevant for the sun. This because of the minuteness, here on earth, of any potential change in our relative distance from the sun. For all practical purposes, then, the sun is infinitely bright; it is the only light source that does not fall off appreciably as the distance from the light source increases. Of course, this is not the case with window light, where the light-emitting window, rather than the sun, is the light source. As all photographers who have ever had to work with window light know, light does fall off the farther you get from the window.

but not light. Black flock or velvet backgrounds are often used to create dense black backgrounds because they absorb all of the light striking their surfaces.

The Intensity of Light

Another characteristic of light has to do with intensity. Illumination from a light source declines considerably over distance, which is to say that the light grows weaker as the distance increases between the light source and the subject. Light from sources other than the sun (see sidebar) falls off predictably in its intensity.

Put precisely, the Inverse Square Law states that the reduction or increase in illumination on a subject is inversely proportionate to the square of the change in distance from the point source of light to the subject. For example, if you double the distance from the light source to the subject, then the illumination is reduced to one quarter of its original intensity. Conversely, if you halve the distance, the light intensity doubles. This law holds true because, at a greater distance, the same amount of energy is spread over a larger area. Thus any one area will receive less light.

The Color of Light

When we look at a visible light source, it appears to be colorless or white. However, it is actually a mixture of colors that the eye *perceives* as white. We know this because if you shine "white" light through a prism, you get a rainbow of colors, which are the individual components of the visible spectrum.

Yet, while the human eye perceives most light as white, few light sources are actually neutral in their color. Most have some some color cast, be it the yellow tint of household incandescent light bulbs, or the green color cast of many fluorescents. The color of light is measured in degrees Kelvin (K) and, therefore, known as the color temperature. The Kelvin scale, like the Fahrenheit and Centigrade scales, is used to measure temperature. It was devised in the 1800s by a British physicist named William Kelvin, who heated a dense block of carbon (also known as a "black body" radiator) until it began to emit light. As more heat was applied, it glowed yellow, and then white, and finally blue. The temperature at which a particular color of light was emitted is now called its color temperature. As you can see in the chart below, natural and artificial light sources have many different color temperatures.

While the human eye perceives most light as white, few light sources are actually neutral.

DAYLIGHT COLOR TEMPERATURES

Clear blue sky	8000–27,000K
Misty daylight	7200–8500K
Overcast	6500–7200K
Direct sun, blue sky	5700–6500K
Midday sun (9:00AM–3:00PM)	5400–5700K
Sun at noon	5000–5400K
Early morning or late afternoon	4900-5600K
Sunrise or sunset	2000–3000K

ARTIFICIAL LIGHT COLOR TEMPERATURES

Fluorescent, daylight-balanced	6500K
Electronic flash	6200–6800K
Fluorescent, cool white	4300K
Photoflood	3400K
Tungsten-halogen	3200K
Fluorescent, warm white	3000K
General-purpose lamps (200–500W)	2900K
Household lamps (40–150W)	2500–2900K
Candle flame	2000K

Infrared film is sensitive to both the visible spectrum and the infrared spectrum. By nature, it is highly unpredictable in the color it produces and the exposure time needed to produce an adequate exposure. Reed Young made this shot with a yellow #15 filter over the lens and the ISO set to 320. He shot this image on a cloudy day, which he finds to be the best light for color infrared film.

Achieving Color Balance. It is important to understand color temperature, because achieving the desired color balance in an image often requires compensating for the color of the light source. This is most commonly accomplished through film selection, filtration, or white balance selection.

Daylight films are balanced to render colors accurately when photographing under light with a color temperature of 5500K. Therefore, they produce the most accurate color during the middle of the day (9:00AM to 3:00PM). Earlier and later than these hours, the color temperature dips, producing a warmer-toned image in the yellow to red range. Tungsten films, on the other hand, are balanced for a color temperature of 3200K, considerably warmer than daylight. In the film world, color balance can also be accomplished using color-compensating filters when recording an image under an off-balance light source.

In the digital world, things are much simpler; you merely adjust the white-balance setting of the camera to match the color temperature of the light. Digital SLRs have a variety of white-balance presets, such as daylight, incandescent, and fluorescent. Custom white-balance settings can also be created

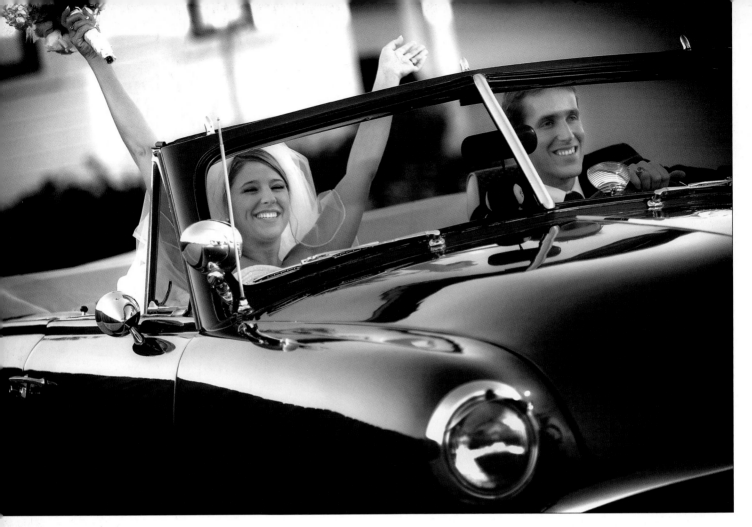

in-camera by taking a reading off a white card illuminated by the light source in question. When precision color balance is critical, a color-temperature meter can be used to get an exact reading of the light's color temperature in Kelvin degrees. That figure can then be dialed into the white-balance system of many cameras.

Reflected Light Values

There are three distinct values of reflected light: specular highlights, diffused highlights, and shadow values. These are sometimes referred to collectively as lighting contrast.

Specular Highlights. Specular values refer to highlights that are pure paper-base white and have no image detail. Specular highlights act like mirrors of the light source. Specular highlights exist within diffused highlight areas, adding brilliance and depth to the highlight.

Diffused Highlights. Diffused highlight values are those bright areas with image detail.

Shadow Values. Shadow values are areas that are not illuminated or partially illuminated.

Small focused light sources have higher specular quality because the light is concentrated in a small area. Larger light sources like softboxes and umbrellas have higher diffused highlight values because the light is distributed over a larger area, and it is scattered.

ABOVE—As the sun sets, it turns the sky into a massive softbox that gently lights everything in a diffused glow—perfect for both portraits and automobile photography. Here, DeEtte Sallee photographed the bride and groom in their vintage convertible. The image was made with the equivalent of a 265mm lens on a Nikon D2X.

FACING PAGE, TOP—A great family portrait captures the warmth and love between family members. In this portrait by Judy Host, a mother and her two children bask in the cool shade. Judy enhanced the image with diffusion and grain effects in Photoshop, lending an emotional quality. Notice that the color balance of the sunlit portion of the scene is very warm and the shady portion of the scene is neutral. This is one of the benefits of digital capture; you can have two completely normal color balances in the same scene.

FACING PAGE, BOTTOM—This elegant shot of mother and daughter was given an ethereal feeling by the addition of atmospheric fog in Photoshop. The original image was made at twilight with no fill-in light, so the posing had to be perfect, since the forms (rather than the surface texture and details) were what was important. The twilight rendered all parts of the image in a soft glow of light. Photograph by Gary Fagan.

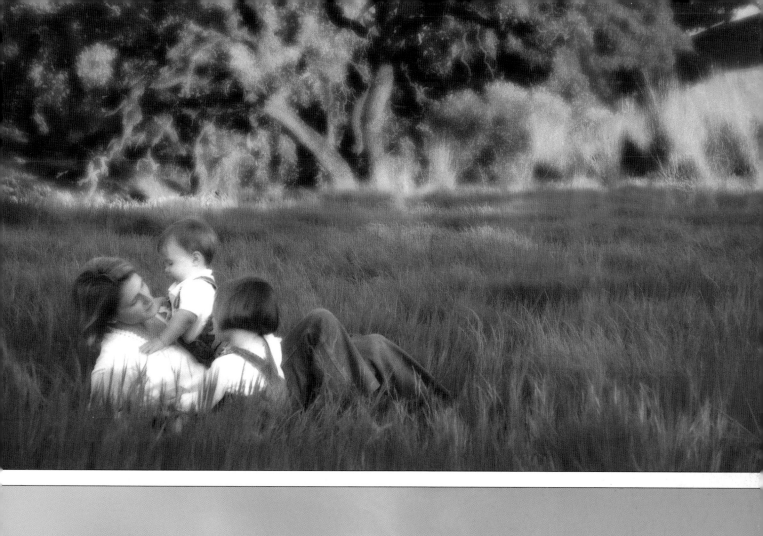

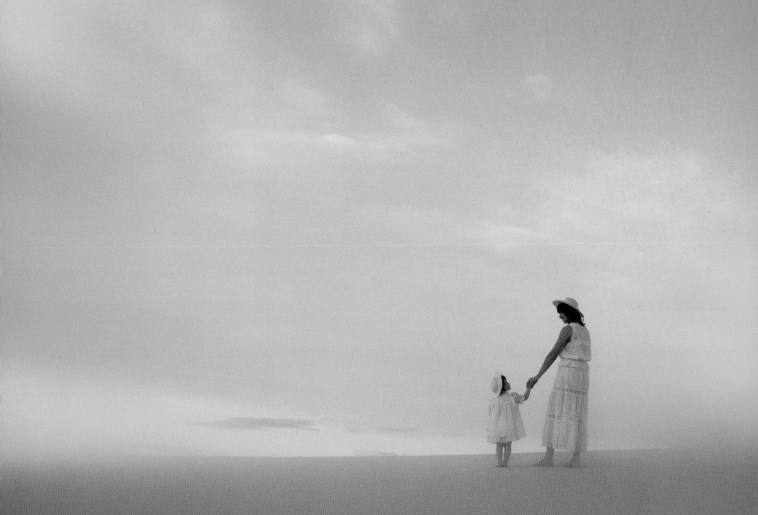

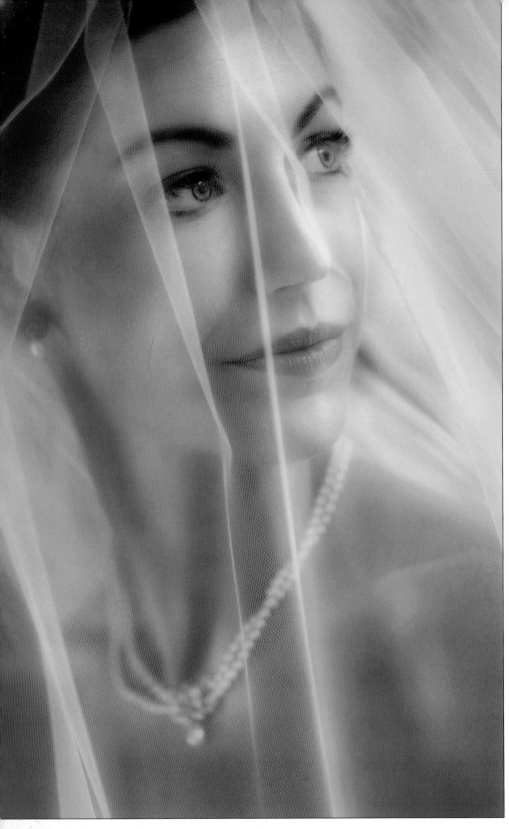

Charles Maring is a gifted lighting technician, knowing both how to light a scene and how to expose the image to bring out the very best qualities of the light. In this image you have diffuse specular highlights (along the bridge of the bride's nose and on her forehead), diffused highlights (on the frontal planes of her face), and soft shadow values with a diffused shadow transfer edge (the transition from highlight to shadow). It is a lighting masterpiece.

With larger light sources, the transfer edge is typically more gradual.

The region where the diffused highlight meets the shadow value, called the shadow transfer edge, also differs between these two types of light sources. Depending on the size of the light, the distance of the light from the subject, and the level of ambient or fill light, the transition can be gradual or dramatic. With a small light, the transfer edge tends to be more abrupt (depending, again, on the level of ambient light). With larger light sources, the transfer edge is typically more gradual.

■ THE THREE-DIMENSIONAL ILLUSION

The human face is sculpted and round; it is the job of the portrait, fashion, or editorial photographer to reveal these contours. This is done primarily with highlights and shadows. Highlights are areas that are illuminated by a light source; shadows are areas that are not. The interplay of highlight and shadow creates the illusion of roundness and shows form. Just as a sculptor models the clay to create the illusion of depth, so light models the shape of the face to give it depth and dimension. A good photographer, through accurate control of lighting, can reliably create the illusion of a third dimension in the two-dimensional medium of photography.

Now that we have covered the basic concepts that control how light behaves, we can begin to explore the ways photographers put this knowledge to work when working with existing light. This chapter presents the basic concepts involved in photographic lighting. We'll continue to explore more specialized techniques in subsequent chapters.

Two Primary Lights

The lights that create virtually all lighting patterns and effects are the key light and the fill light. Even though many different lights may be used in any given photograph, the effect should be the same: that of a key light and a fill light. As noted previously, our human perception is so accustomed to the sun providing our single source of light, that we are happiest when artificial lighting arrays mimic that effect.

Key Light. The key light is what creates form, producing the interplay of highlight and shadow. Where you place the key light will determine how the

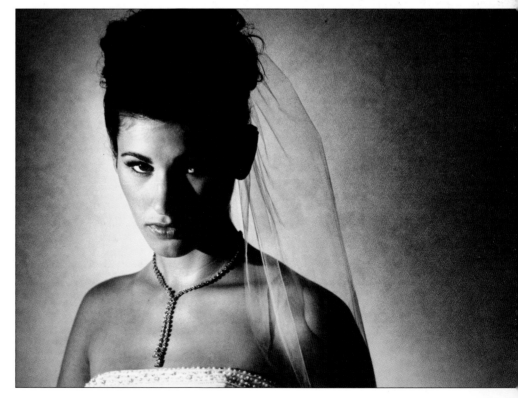

The job of the key light is to create direction and form and to establish a lighting pattern. Here, Cherie Steinberg Coté had her assistant hold a single key light (an undiffused Mole Richardson 1K light) above and to the side of the bride to produce a dramatic Rembrandt lighting pattern (note the diamond-shaped highlight on the shadow side of her face). This overpowered the existing light to establish a dominant lighting pattern with no fill. Had the main light's intensity been reduced, the existing light would have lightened the shadow side of her face.

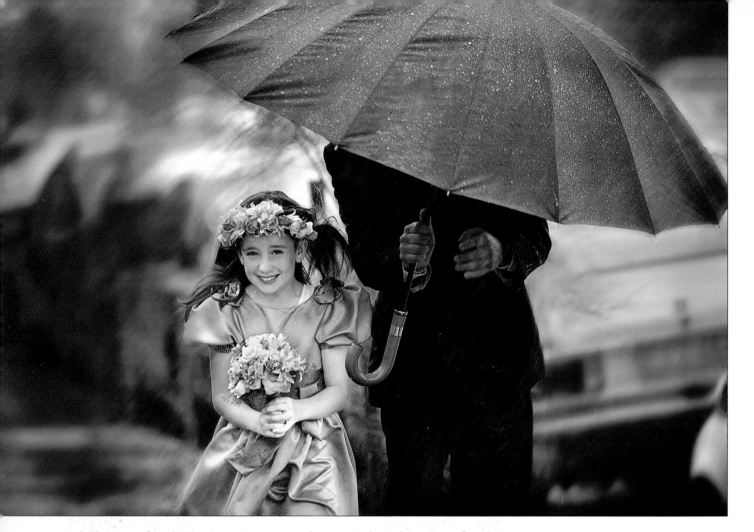

subject is rendered. You can create smoothness on the subject's surface by placing the light near the camera and close to the camera/subject axis, or you can emphasize texture by skimming the light across the subject from the side.

The placement of the key light relative to the subject is of critical importance, and one of the key elements that must be considered when working with existing light. Outdoors, the existing light is often too overhead in nature, producing an unflattering effect on the subject. If existing light will provide the key light for your portrait, it is important to look for a shooting area where the light is blocked from above and allowed to filter in only from the sides—at the edge of a stand of trees, on a porch, under a roof overhang, etc. Indoors, good key-light sources can be found near windows and doors.

Indoors or out, a good starting point, recommended by master photographer Fuzzy Duenkel, is finding a bright area with the light at about a 2 o'clock height and coming from about 30 degrees to the right or left. Once you have found your key light source, note that you will need to position your subject within the light to achieve the desired effect. Unlike studio lights, existing light sources usually can't be moved, so your only controls are distance at which you position your subject from the key light and the angle at which the subject is turned. Fuzzy suggests turning the subject's body toward the light if their outfit is dark. Light outfits, on the other hand, may need to be turned away from the light to reduce light reflecting off the fabric and to emphasize texture—as you would do for a bride, for example.

Mercury Megaloudis photographed this wonderful action portrait of a flower girl attempting, with the help of the chauffeur, to stay dry. The black umbrella acted as a gobo, blocking the overhead light and letting it filter in from the sides to create a more pleasing portrait-type light. He used a slowish shutter speed to blur the raindrops and "helped" the falling rain in the background, which was soft, with a little motion blur in Photoshop. This is an award-winning image.

Fill Light. The light source that makes the "shadow side" of things visible is called the fill light. The fill light is defined as a secondary light source because it does not create visible shadows. Over the years, photographers have found that the best way to achieve this shadow-filling effect is to place the fill light as close as possible to the camera-subject axis. All lights, no matter where they are or how big, create shadows. But by placing the fill light as near the camera as possible, all the shadows that are created by that light are cast behind the subject and are therefore less visible to the camera. Just as the key light defines the lighting, the fill light augments it, controlling the intensity of the shadows created by the key light.

■ REFLECTED LIGHT

Sun lighting up green grass in front of or to the side of the subject can cause areas of the face to be rendered green, which is not very attractive. One way to correct that, according to Fuzzy Duenkel, is to block that green reflected light with a large, black gobo. Similarly, if blue sky is the key light source, then the fill reflector must also reflect blue sky to keep the planes of the face lit with the same color. A reflector with a mirrored or silver surface works best.

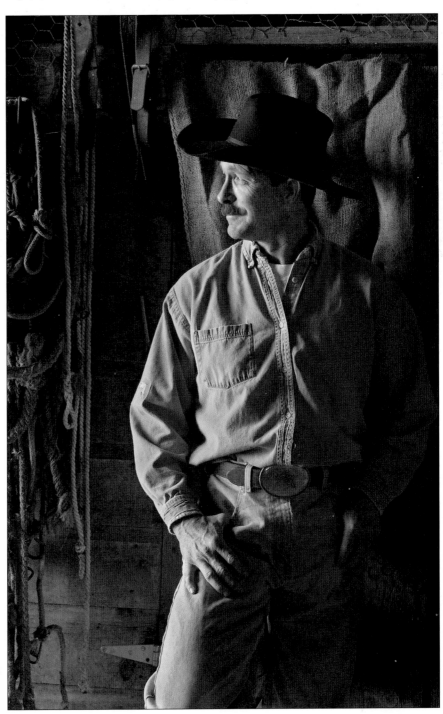

Bright highlights and deep detailed shadows make this profile by Gary Fagan a memorable portrait. Gary used the daylight filtering in through open barn doors to light his subject. He used no fill and allowed the skimming light to bring out all of the texture in the cowboy's face and clothing. The inclusion of all the ropes and background make this portrait even more authentic.

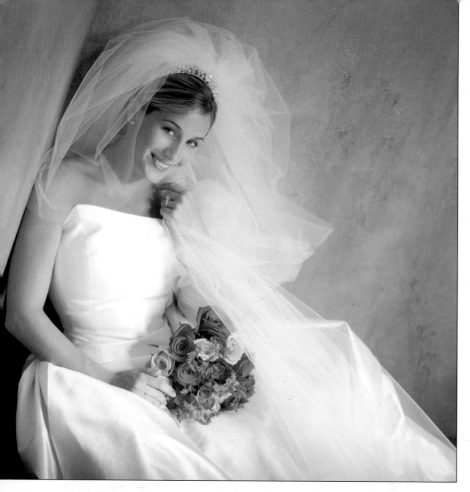

LEFT—Fill light works to lighten the shadows created by the key light. Here, Drake Buasth used an umbrella-mounted flash as a soft key light and the neutral-colored wall provided the fill illumination on her face. Because the image was taken outdoors in an alcove, there is a base level of existing light that mixed with the scattered light from the umbrella to create the overall fill-light level.

BOTTOM LEFT—Even when the lighting is very soft and ethereal, there still needs be a ratio between highlight and shadow in order to convey dimension and drama. In this very soft image by Mauricio Donelli, a 3:1 or even a little greater ratio is attained by not using a strong fill source. Mauricio brings strobes and assistants to every wedding so that he can combine umbrella lighting with existing light to create memorable images like this. In this case, the available light contributed to the fill illumination, but it was considerably less than the strobe output, accounting for the medium to strong lighting ratio.

BOTTOM RIGHT—Large light sources will often exist at your wedding venues. For instance, Scott Robert Lim used a bank of windows covered with sheers to create a beautiful wall of light with which to photograph his bride. She is seated no more than six feet from the windows, making the effect much like softbox lighting in the studio.

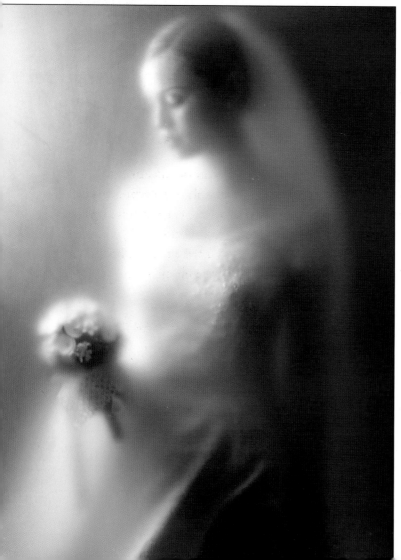

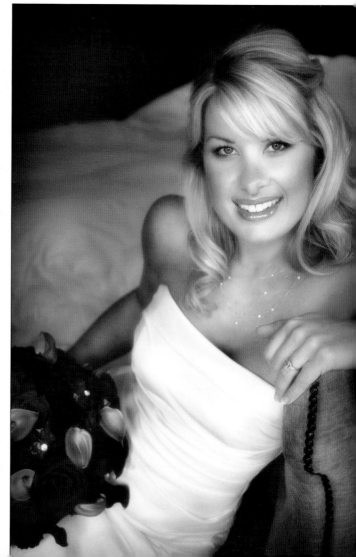

Cross lighting can be a problem unless the light sources are diffused and weak. Here; Dan Doke captured this elegant portrait that is lit from either side of the bride by two reflective sources. There is enough ambient light in the scene that neither light source attains dominance. He selectively diffused areas of the portrait to make it a dreamy masterpiece.

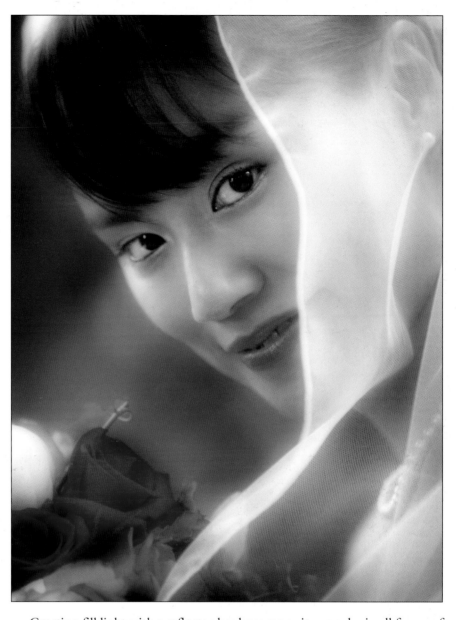

Smaller light sources produce

a sharper transition

from highlight to shadow

Creating fill light with a reflector has become quite popular in all forms of photography. The reflectors available today are capable of reflecting any percentage of light back on to the subject—from close to 100 percent reflectance with various mirrored or Mylar-covered reflectors, to a very small percentage of light with other types. Reflectors can also be adjusted almost infinitely just by finessing the angle at which they are reflecting the fill-in light.

Size of the Light

The size of the light source affects the results you will produce. Small light sources create tiny shadows across a surface; larger light sources, on the other hand, tend to automatically fill in the shadows because of the wraparound quality of the light.

Smaller light sources produce crisper shadows with a sharper transition from highlight to shadow across the subject. If you want texture, which often equates to drama (especially when minimal fill-in illumination is employed in the image), use a small light source.

Larger light sources produce softer shadows with a more even gradation from highlight to shadow. If you want smoothness or softness, use a large light source. Larger light sources tend to be more forgiving and easier to use, but they reveal less texture.

The effective size of a light source is determined both by the physical size of the source itself and its distance to the subject. Man-made light sources are physically very small, but they can be made larger by placing them in a light-modifying device like a softbox or umbrella. Natural light originates from the sun, a very small source, but can be made softer by diffusing it (for more on this see chapter 4).

Metering

Exposure is critical to producing fine portraits, so it is essential to meter the scene properly. Using the in-camera light meter may not always give you consistent and accurate results. In-camera meters measure reflected light and are designed to suggest an exposure setting that will render subject tones at a value of 18-percent gray. This is rather dark even for a well-suntanned or dark-skinned individual. So, when using the in-camera meter, you should meter off an 18-percent gray card held in front of the subject—one that is large enough to fill most of the frame. (If using a handheld reflected-light meter, do the same thing; take a reading from an 18-percent gray card.)

A better type of meter for portraiture is the handheld incident-light meter. This does not measure the reflectance of the subject; instead, it measures the amount of light falling on the scene. To use this type of meter, simply stand where you want your subject to be, point the hemisphere of the meter directly at the camera lens, and take a reading. Be sure that the meter is held in exactly the same light that your subject will be in. This type of meter yields extremely consistent results and is less likely to be influenced by highly reflective or light-absorbing surfaces. (A good rule of thumb when setting your lights is to point the meter at the light source if only one light source is being measured; if multiple lights are being metered, point the dome of the meter at the camera lens.)

A handheld incident flashmeter is useful for determining lighting ratios—and crucial when mixing flash and daylight. Flashmeters are also invaluable when using multiple strobes and when trying to determine the overall evenness of lighting in a large-size room. Flashmeters are ambient incident-light meters, meaning that they measure the light falling on them and not light reflected from a source or object, as the in-camera meter does.

Lighting Ratios

A lighting ratio is a numeric expression of the difference in intensity between the shadow and highlight side of the face in portraiture. A ratio of 3:1, for example, means that the highlight side of the face has three units of light falling on it, while the shadow side has only one unit of light falling on it. Ratios are useful because they describe how much local contrast there will be in the portrait. They do not, however, reflect the overall contrast of the scene.

Using the in-camera light meter may not always give you accurate results.

Since lighting ratios tell you the difference in intensity between the key light and the fill light, the ratio serves as an indication of how much shadow detail you will have in the final portrait. Since the fill light controls the degree to which the shadows are illuminated, it is important to keep the lighting ratio fairly constant. A desirable ratio, whether indoors or out, is 3:1. This ratio guarantees both highlight and shadow detail and is useful in a wide variety of situations.

Determining Lighting Ratios. There is considerable debate and confusion over the calculation of lighting ratios. This is principally because you have two systems at work, one arithmetical and one logarithmic. F-stops are

Lighting ratios tell you the difference in intensity between the key light and the fill light.

Although this looks like a high lighting ratio (because of the bride's makeup is applied more densely beneath the cheekbones to provide contouring), it is actually fairly close to 2:1—perhaps a 2.5:1. The light is very diffuse and large, comparatively speaking, providing gentle highlights and soft lighting that is perfect for this portrait. Photograph by Marcus Bell.

A 3:1 ratio was achieved outdoors by using a small reflector to raise the shadow level—and by having the child look up into the overhead shade, illuminating the recesses of the face, like the eye sockets. Stacy Bratton, a well known children's portrait artist, made this image with a wide-open aperture to diminish overall sharpness. Note the beautiful hair light provided by the soft overhead lighting.

This requires a suspension of disbelief, but it helps make the system explainable.

in themselves a ratio between the size of the lens aperture and the focal length of the lens, which is why they are expressed as "f/2.8," for example. The difference between one f-stop and the next full f-stop is either half the light or double the light. For example f/8 lets in twice as much light through a lens as f/11 and half as much light as f/5.6. However, when we talk about lighting ratios, each full stop is equal to two units of light, each half stop is equal to one unit of light, and each quarter stop is equivalent to half a unit of light. This requires a suspension of disbelief, but it helps make the system explainable and repeatable.

In lighting of all types, from those made in sunlight to those made in the studio, the fill light is calculated as one unit of light, because it strikes both the highlight and shadow sides of the face. The amount of light from the key light, which strikes only the highlight side of the face, is added to that number. For example, imagine you are photo- graphing a small family group and the key light is one stop (two units) greater than the fill light (one unit). The one unit of the fill is added to the two units of the key light, yielding a 3:1 ratio; three units of light fall on the highlight sides of the face, while only one unit falls on the shadow sides.

LEFT—In this elegant portrait by Anthony Cava, the man's rugged good looks cried out for a dramatic 5:1 lighting ratio. The ratio was controlled by increasing the distance of the subject from the light source. The farther he is from the window light, the more focused and contrasty the light becomes.

FACING PAGE—In traditional terms, one might say this lighting lacks drama. However, in contemporary circles—and more importantly, to the brides who cherish such images—very soft lighting is perfect and very editorial. In this image by Becker, the lighting ratio is about as close to 1:1 as you can get. The image is very soft with very little differentiation between shadow and highlight values. Yet, notice the exquisite detail in the gown. The only near-black tones are created in the vignette, by the photographer in Photoshop.

Lighting Ratios and Their Unique Personalities. A 2:1 ratio is the lowest lighting ratio you should employ. It reveals only minimal roundness in the face and is most desirable for high-key effects. High-key portraits are those with low lighting ratios, light tones, and usually a light or white background (see page 33). In a 2:1 lighting ratio, the key and fill-light sources are the same intensity (one unit of light falls on the shadow and highlight sides of the face from the fill light, while one unit of light falls on the highlight side of the face from the key light—1+1:1=2:1). A 2:1 ratio will widen a narrow face and provide a flat rendering that lacks dimension.

A 3:1 lighting ratio is produced when the key light is one stop greater in intensity than the fill light (one unit of light falls on both sides of the face from the fill light, and two units of light fall on the highlight side of the face from the key light—2+1:1=3:1). This ratio is the most preferred for color and black & white because it will yield an exposure with excellent shadow and highlight detail. It shows good roundness in the face and is ideal for rendering average-shaped faces.

A 4:1 ratio (the key light is 1½ stops greater in intensity than the fill light—2+1+1:1=4:1) is used when the photographer wants a slimming or dramatic effect. In a 4:1 ratio, the shadow side of the face loses its slight glow and the accent of the portrait becomes the highlights. Ratios of 4:1 and higher are considered appropriate for low-key portraits, which are characterized by a higher lighting ratio, dark tones, and usually a dark background (for more on low-key portraits, see page 35).

A 5:1 ratio (the key light is two stops greater than the fill light—2+2+1:1=5:1) is considered almost a high-contrast rendition. It is ideal for adding a dramatic effect to your subject and is often used in character stud-

■ **SCENE CONTRAST**

Lighting ratios determine contrast and to what degree the light will slim the subject's face. The higher the lighting ratio (the greater the tonal difference between highlight and shadow sides of the face will be), the thinner the subject's face will appear. The ratio is also an indication of how much shadow detail you will have in the final portrait. A desirable ratio for color film or digital is 3:1, which is flattering to the average face and provides plenty of shadow detail.

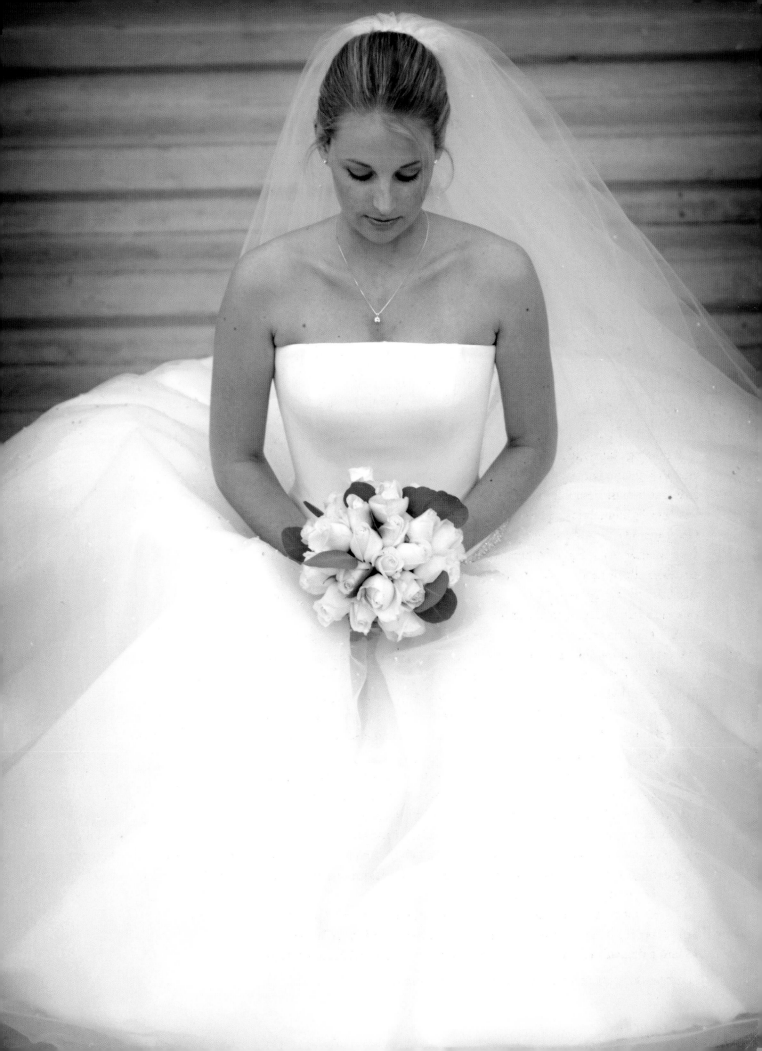

ies. Shadow detail is minimal with ratios of 5:1 and higher. As a result, they are not recommended unless your only concern is highlight detail.

Seasoned photographers are able recognize the very subtle differences between lighting ratios, so fractional ratios (produced by reducing or increasing the fill light amount in quarter-stop increments) are also used. For instance, a photographer might recognize that with a given face, a 2:1 ratio does not provide enough roundness and a 3:1 ratio produces too dramatic a rendering, thus he or she would strive for something in between—a 2.5:1 ratio.

High-Key Lighting

There are a number of ways to produce high-key portrait lighting, but all require that you overlight your background by 1½ to 2 stops. For instance, if the main subject lighting is set to f/8, the background lights should be set at f/11 to f/16. Sometimes photographers use two undiffused light sources in reflectors at 45-degree angles to the background, feathering the lights (angling them) so that they overlap and spread light evenly across the background. Other setups call for the background lights to be bounced off the ceiling onto the background. In either case, they should be brighter than the frontal lighting so that the background goes pure white. Because light is being reflected off a white background back toward the lens, it is a good idea to use a lens shade to minimize flare, which will often occur in high-key setups.

These photos show the difference between a high-key treatment with a normal lighting ratio (facing page) and a true high-key treatment (below). In the vertical image, Mike Colón concentrated on lightening the background and wedding dress without losing detail, but the light on the bride's face still has a significant ratio—almost 3:1. In the horizontal image, the background light, which is overpowering, rim lights every feature of the bride. The detail in the shadow side of the image is a function of Mike handling the exposure of the image expertly.

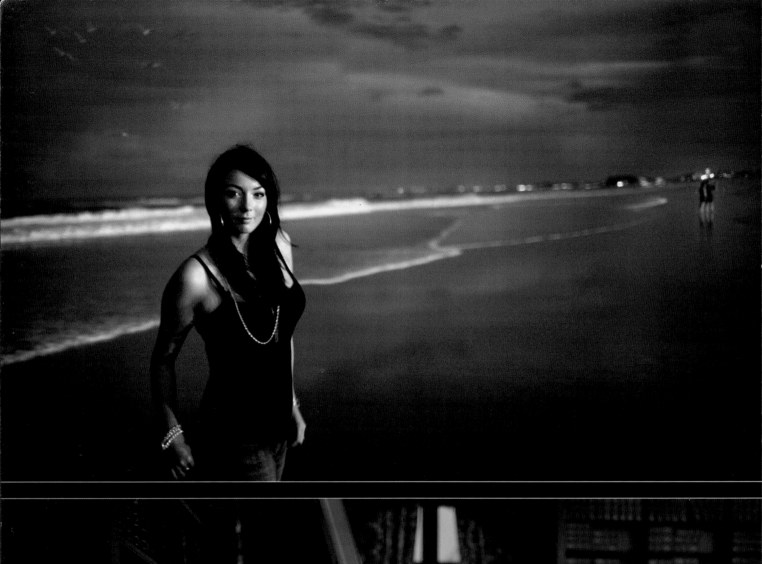
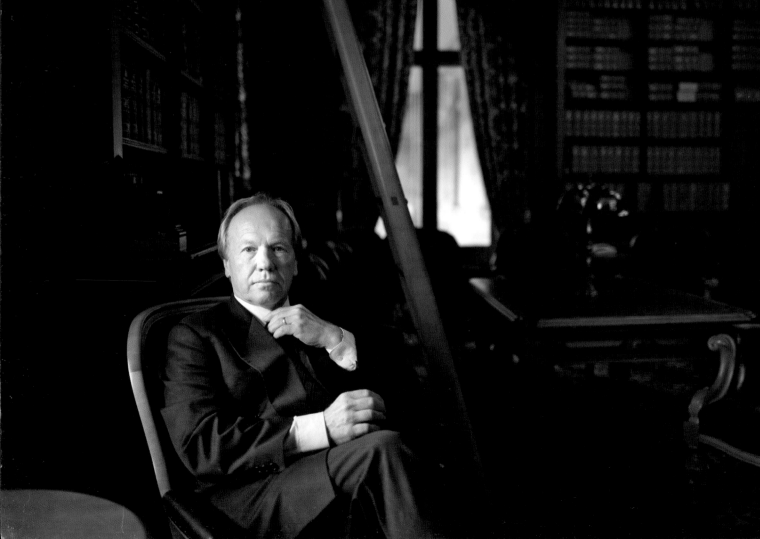

FACING PAGE—Here are two great examples of low-key portraits made by Marcus Bell. The man is the Premier of the Australian state of Queensland, Peter Beattie. Marcus used window lighting with no fill and extinguished all other lights in Beattie's office to make the lighting more dramatic. The subject of the beach portrait is Ricki-Lee Coultier, winner of the television show *Australian Idol*. Marcus photographed her late in the day when there was just enough twilight to record shadow detail, adding a diffused strobe at camera right to create a low-key effect. No fill light was used and the image was given more darkness and drama in printing.

Low-Key Lighting

Low-key is the opposite of high-key lighting. It uses strong lighting ratios and lots of dramatic dark tones created by pairing little or no fill light with a sharp-edged or weak key light. Sometimes grid lights are used (grids narrow the light by channeling it down through small honeycomb openings in the light baffle). Window light can also be an effective low-key light source if used without a fill. Sometimes a black gobo is used opposite the key light to further deepen the shadows. Low-key lighting is often used to slim the appearance of large-figured people, since it is relatively easy to "hide" major portions of the person's body in blackness.

FOCUSING ACUMEN, MINIMAL WINDOW LIGHT, AND MAXIMUM APERTURE

Cliff Mautner makes it a habit to create a stunning portrait as soon as the bride is dressed in her gown. He wants this to be the best photograph anyone has ever made of her, but this can often be a challenge. Many of his weddings take place in Center City Philadelphia hotels—rooms that do not offer much in the way of photographic backgrounds. If the weather is inclement, the challenge becomes even greater.

The portrait above was made with a Nikon D200 and 85mm f/1.4D AF Nikkor lens. Cliff uses only fast prime lenses, allowing him to isolate precise areas of his subject and eliminate distracting backgrounds by knocking them out of focus with a very shallow depth of field. In this case, the bride had beautiful eyes and eyelashes. To emphasize them, Cliff shot some straightforward images of her looking directly at the camera, then had her look down. The D200 has eleven different focus points in the viewfinder, and Cliff chose the upper left focus point to concentrate on her eyelashes, exposing several frames at $1/200$ second f/1.4. (*Note:* When photographing wide open, it is important to choose the focus point in the specific region you are planning on highlighting, rather than center-focusing and then recomposing; moving the plane of the focus point will knock the specified area out of focus due to the shallow depth of field.)

The only light in this image is window light. Cliff asked the bride to crouch down like a baseball catcher and he stood above her on the windowsill. Photographing downward adds a steep angle to the photograph and makes the focus fall-off more pronounced; thus the eyelashes appear extremely in focus and the rest of her is out of focus. Cliff also used a bedspread as a makeshift seamless backdrop, eliminating the distracting pattern of the hotel carpet.

This portrait is a great example of how, with limited resources, it is possible to create incredible images by controlling your environment, making the most of the existing light, and using your lens and camera controls to best effect. To complete this image, Cliff converted it to black & white, then applied a slight Diffuse Glow in Photoshop, allowing the eyelashes to pop out.

3. Portrait Lighting Fundamentals

The basic function of portrait lighting is to illuminate the subject and to create the illusion of three-dimensional form in a two-dimensional medium. While lighting has an aesthetic function, helping to idealize the subject or creating a romantic or sentimental mood, the functional aspects of portrait lighting are to show roundness and contouring in the human face and form. Good lighting also reveals the textural qualities of skin. Lighting should create a balanced sense of realism and idealism, and a heightened sense of dimension and depth.

Broad and Short Lighting

There are two basic types of portrait lighting: broad lighting and short lighting.

Broad lighting means that the key light is illuminating the side of the face turned toward the camera (the side of the face that is widest from the camera's perspective). Broad lighting is used less frequently than short lighting because it tends to flatten out and de-emphasize facial contours, minimizing form. It can, however, be used to widen a thin or long face. Broad lighting places three-quarters of the face in highlight. A low-contrast, large key light source works best for this type of lighting. Broad lighting is normally used with higher key lighting setups. Broad lighting almost requires a very thin face to withstand its broadening characteristics.

Short lighting means that the key light is illuminating the side of the face turned away from the camera (the side of the face that is narrowest from the camera's perspective). Short lighting emphasizes facial contours, and can be used as a corrective lighting technique to narrow a round or wide face. When used with a weak fill light, short lighting produces a dramatic lighting effect with bold highlights and deep shadows. Short

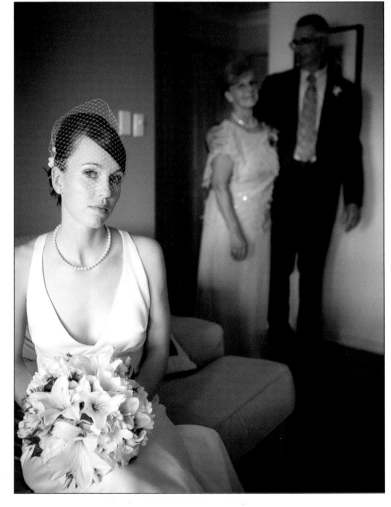

Marcus Bell, realizing the thinness of the bride's face and figure, chose broad lighting to illuminate his bride. The light source is diffused window light. The light falloff from the bride to the bride's parents in the background helps produce a secondary portrait within the bridal portrait. But in order to not take emphasis away from the bride, the parents are tonally much darker.

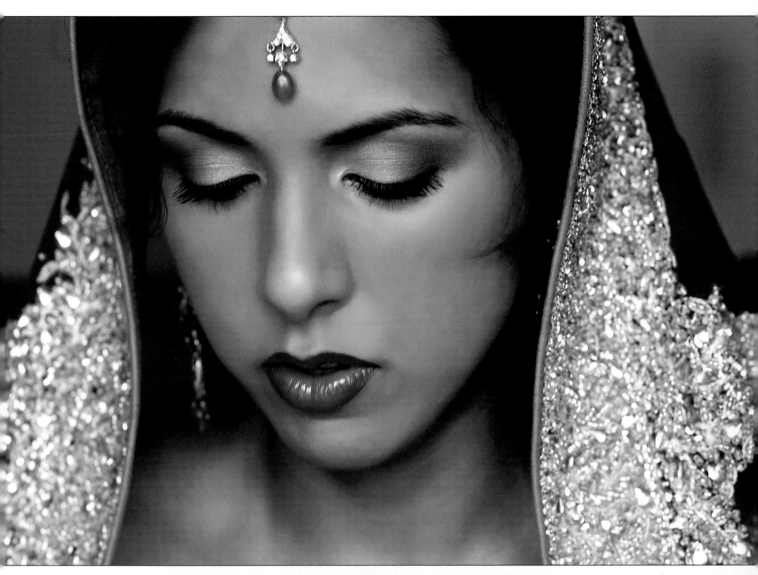

ABOVE—Broad lighting, used much less frequently than short lighting, occurs when the more visible side of the face is highlighted. Photograph by Cherie Steinberg Coté.

RIGHT—A short lighting scenario is created by the main light being 45 degrees to camera left and photographing "into" the shadow side of the bride's face. The lighting ratio is dramatic, but detailed—around 3.5:1. Photograph by Fernando Basurto.

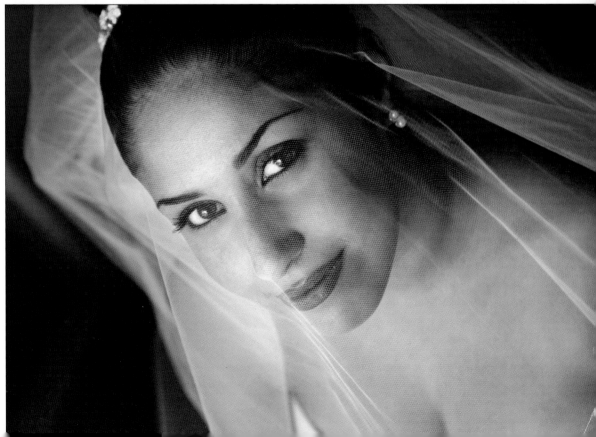

Mark Nixon created this wonderful portrait with a single large light positioned in close to the child. Working on location in the child's home, the high-key background was produced by lighting a white seamless backdrop with two strobes at 45 degree angles to the background. The background was 1½ stops more intense than the subject lighting so that it would record as pure white. The existing light in the room provided fill light.

lighting is by far the more prominent of the two types of lighting and is used most often for average-shaped faces.

When working with existing light as your key, the difference between broad and short lighting can be as insignificant as turning the subject's head 15 degrees to the right or left, toward or away from the key light. The more the light comes from the side, the more likely it is you will be creating a short-lit portrait.

The Five Basic Portrait Lighting Setups

In traditional portraiture, there are five basic lighting patterns that are used repeatedly. These five lighting patterns (and countless variations on them) are established methods of lighting the human form. They all stem from the notion that, as in nature, all light should emanate from a single source like the sun.

Since this book is about existing light portraiture, the studio setups for each of the major portrait lighting setups will not be covered in detail. However, the patterns themselves, which are all possible to execute using existing light, will be covered here.

Paramount Lighting. Paramount lighting, sometimes called butterfly lighting or glamour lighting, is traditionally a feminine lighting pattern that produces a symmetrical, butterfly-like shadow beneath the subject's nose. It emphasizes high cheekbones and good skin. It is generally not used on men because it tends to hollow out their cheeks and eye sockets too much.

To create Paramount lighting, the key light is elevated and directly in front of the subject's face, parallel to the vertical line of the subject's nose (see di-

In traditional portraiture, there are five basic lighting patterns that are used repeatedly.

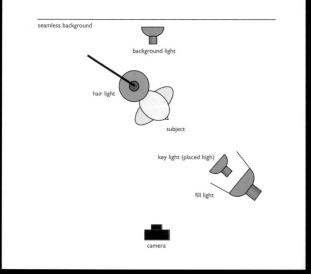

PARAMOUNT LIGHTING

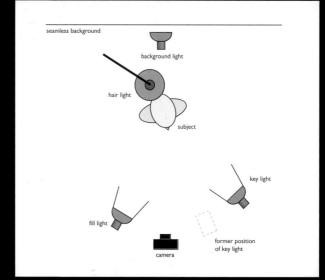

LOOP LIGHTING

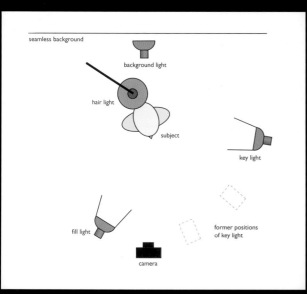

REMBRANDT LIGHTING

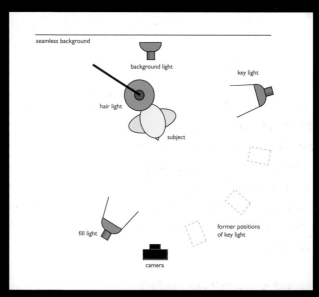

SPLIT LIGHTING

These diagrams show the five basic portrait lighting setups. The fundamental difference between them is the placement of the key light. Lighting patterns change as the key light is moved from close to and high above the subject to the side of the subject and lower. The key light should not be positioned below eye level, as lighting from beneath does not occur in nature. You will notice that when the key and fill lights are on the same side of the camera, a reflector is used on the opposite side of the subject to fill in the shadows.

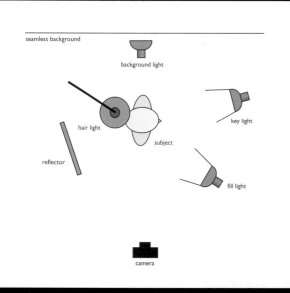

PROFILE OR RIM LIGHTING

agram), similar to the position of the 11 o'clock sun. Since the light must be high and close to the subject to produce the desired butterfly shadow, it should not be used on subjects with deep eye sockets, or no light will illuminate the eyes—even with adequate fill.

The fill light or reflector is placed beneath the subject's head height directly under the key light. Since the key and fill lights are on the same side of the camera, a secondary reflector should be used on the opposite side from the lights and close to the subject to fill in the deep shadows on the neck and cheek.

Loop Lighting. Loop lighting is a minor variation on Paramount lighting. The key light is lower and more to the side of the subject so that the shadow under the nose becomes a small loop on the shadow side of the face.

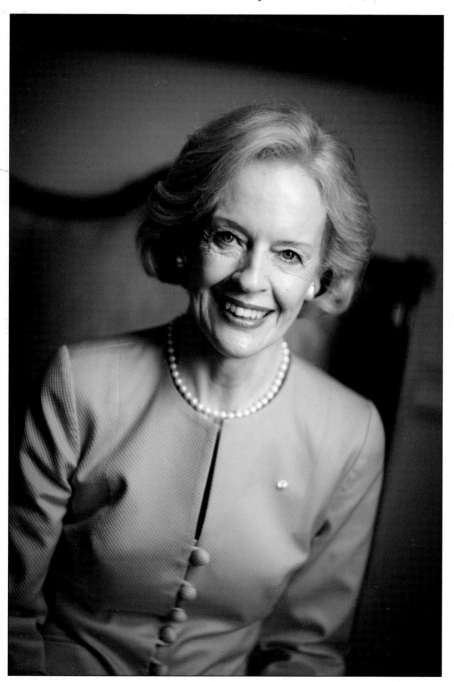

■ THE KEY LIGHT FOLLOWS THE SUN

As you progress through the lighting setups from Paramount to split lighting, each progressively makes the face slimmer. Each also progressively brings out more texture in the face because the light is more to the side, thus revealing surface texture. Note how, in this progression, the key light position relative to the subject also mimics the setting sun—at first high, and then gradually lower. It is important that the key light never dips below subject/head height, however. In traditional portraiture this does not occur, primarily because it does not occur in nature.

Marcus Bell used umbrella lighting to create a hybrid lighting look that falls in between a loop and a Rembrandt pattern. He brought out the facial details on Quentin Bryce (Governor of Queensland, Australia) but softened all the other details of the image, including the background, the details of her dress, and the chair she is sitting in. This is easily accomplished in Photoshop. Marcus also vignetted the image to draw clear attention to her face. When using umbrella lighting or softbox lighting on location, it is always a good idea to welcome the amount of existing room light and set your exposure accordingly to include that light. This not only builds up background exposure around the room but also adds fill light on the subject.

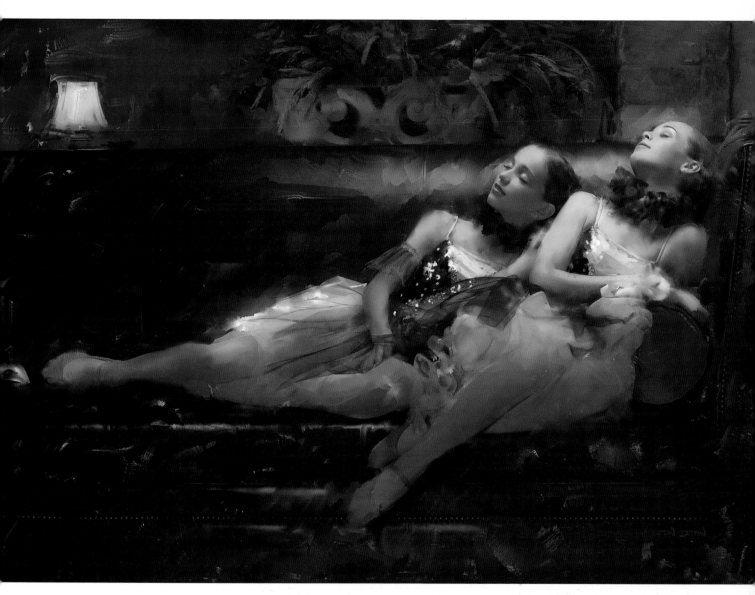

In this classic pose of two young ballet dancers, Bruce Dorn lit the girls from above with soft, focused light that was feathered so that the girls' faces and torsos were well lit, but there was a slight falloff everywhere else. The lighting is glamorous, producing a near Rembrandt lighting pattern on the dancer on the left and more of an open fashion lighting pattern on the dancer on the right. He used the existing light in the room (from several table lamps like the one seen in the background) to illuminate the background and balance the overall light level with the flash exposure. This is the type of lighting situation you will encounter in the field, and having the right tools to add light to the scene can mean the difference between failure and success. Bruce worked the image extensively in Corel Painter, adding brush strokes to create the feeling of an Impressionist painting.

This is one of the more commonly used portrait lighting setups and is ideal for people with average, oval-shaped faces.

In loop lighting, the fill-light source is moved on the opposite side of the camera from the key light. It is important that the fill light not cast shadows of its own in order to maintain the one-light character of the portrait. The only way you can really determine whether or not the fill light is effective is by looking through the viewfinder.

Rembrandt Lighting. Rembrandt or 45-degree lighting is characterized by a small, triangular highlight that appears on the shadowed cheek of the subject. The lighting takes its name from the famous Dutch painter who was known for using a skylight to illuminate his portrait subjects. This type of lighting is often thought of as dramatic, and is more typically a masculine style. It is commonly used with a weak fill light to accentuate the shadow-side highlight.

To create Rembrandt lighting, the key light is placed lower and farther to the side than in loop and Paramount lighting. In fact, the key light almost comes from the subject's side, depending on how far the head is turned away

FUZZY DUENKEL PUSHES THE EXTREME EDGE OF EXISTING LIGHT

Fuzzy Duenkel says he can usually judge when the lighting contrast in a scene will be within a recordable and printable range, but occasionally he will still try to get away with "breaking the law." Every time he does, though, he ends up "getting hauled away and handcuffed to my computer to fix my mistake." That was the case with the "before" image (left) of this high school senior. The young man was standing in his family's barn near a silo with an opening overhead, which let in a shaft of light. By positioning him just right, Fuzzy was able to produce a strong, narrow shaft of light streaming through the hole in the silo. The light illuminated his left side.

Fuzzy loved the effect when he saw it. He decided to try pushing the boundaries of dynamic range and attempted to capture the image he saw with his eyes using a Canon 1Ds Mark II. His reasoning was, "I always shoot in RAW format, so I figured if the image was slightly beyond the sensor's capabilities, I could rely on the format's wider range to save the image." Apparently this wasn't the case.

Fortunately, Fuzzy had also decided to play it safe and make a second exposure with modified lighting, just in case the first one didn't work out. In order to diffuse the incoming light, Fuzzy placed a translucent scrim over the silo opening from the outside, which turned the incoming light from a bright shaft of sunlight into a broad, diffused light source, resulting in even illumination and lower contrast.

As you can see, the "after" image (right) is much better and definitely more printable than the first! The lesson here, according to Fuzzy, is that "while our eyes are capable of seeing detail in a wide range of shadows and highlights, cameras are not. If the lighting looks dramatic to your eye, it's probably too dramatic for a sensor to record. That holds true no matter what type of camera or capture mode (RAW vs. JPEG) you use."

Split lighting is dramatic. Here, Heidi Mauracher used the last rays of direct sunlight to create split lighting on her outdoor subject. Using no fill-in caused the highlights, bleached red and yellow by the setting sun, to be prominent.

from the camera. Tilting the head up or down will help correctly position the highlight on the shadow side of the face. To make the triangular shape of the highlight softer and less recognizable, you can opt to diffuse the key light. In Rembrandt lighting, the fill source is used in the same manner as it is for loop lighting.

Split Lighting. Split lighting is created when the key light illuminates only half of the subject's face. It is an ideal slimming light that can be used to narrow a wide face or nose. It can also be used in conjunction with a weak fill light to hide facial irregularities, or even with no fill light for a highly dramatic effect.

In split lighting, the key light is farther to the side of the subject and lower (see diagram, page 39). Sometimes, the key light is even slightly behind the subject, depending on how far the subject is turned from the camera and the light source.

Profile Lighting. Profile or rim lighting is used when the subject's head is turned 90 degrees from the camera lens. It is a dramatic style of lighting used to accent elegant features. It is used less frequently now than in the past, but it is still a very stylish form of portrait lighting.

In profile lighting, the key light is positioned behind the subject so that it illuminates the far side of the face, leaving a highlight along the edge of the profile and accenting the hair and neck of the subject. Care should be taken that the light is centered on the face and not so much on the hair or neck. The fill source should be placed on the same side of the camera as the key light (see diagram, page 39).

Fashion Lighting

Fashion lighting is a variation of conventional portrait lighting. It is extremely soft and frontal in nature. As a result, it does not model the face; it leaves that job primarily to the subject's makeup. This look is most often used in senior

This is a fabulous portrait by Elaine Hughes. It is full of emotion and exposes the woman's graceful neck. Elaine employed outdoor lighting, soft and overhead, and had the bride tilt her head up toward the light, so that highlights would define the frontal "mask" of the face. A thin rim of a highlight exists around the profile of her face, but not her neck; the light being blocked by her chin prevents the neck from getting direct light. The portrait has just a bit of motion to it, further adding to its ethereal effect.

RIGHT—Here is a beautiful variation on profile lighting. Instead of moving the light behind the subject, David Williams positioned it almost directly in front of his subject. The light falls off as it strikes the frontal planes of his face and hand, creating contouring and showing excellent dimension. The image was made by using the existing light that floods in through the French doors that lead into the shooting room in his studio. David varies the width of the main light by opening and closing the French doors until he has the width of light he prefers.

BELOW—This is a great example of perfect profile lighting found in nature. A wooded glen allows sunlight to filter in and edge-light the subjects. The photographer, Ferdinand Neubauer, used a soft-focus filter to diffuse the scene and lower the scene contrast. He biased his exposure to the shadow side of the subjects, letting the backlit highlights overexpose. No flash or fill-in illumination was used.

photography of girls and images that involve professional hairstyling and makeup.

To create fashion lighting, the key light is placed on the lens-to-subject axis. In the studio, this often means placing a large softbox directly over the camera and a silver reflector just beneath the camera for fill. Both the light and reflector are very close to the subject for the softest effect. Sometimes, you may even see a circular catchlight produced by a ring-light flash—a type of light that mounts around the lens for completely shadowless lighting.

In existing light portraiture, fashion lighting can be created using a polished or Mylar-surfaced reflector very close to the lens axis. If redirecting backlighting onto the subject, the Mylar reflector will be way too bright and cause the subject to squint. This can minimized without affecting the frontal nature of the light by positioning a translucent scrim between the reflector and the subject. This will cut the light's intensity and also its brightness.

Here is an example of nearly frontal fashion lighting made with existing daylight. The backlight was warmed and focused with the Mylar-coated side of the Fuzzyflector (for more on this, see page 50), and softened using a translucent scrim between the reflector and the subject. The light is not on the lens axis, but on the axis of the frontal planes of the subject's face. Note that the reflector is below head height, so the photographer, Fuzzy Duenkel, had her look down toward the light.

4. Working with Existing Light

Learn to control and modify the light in order to produce a professionally lit portrait.

In the studio, light sources can be added or removed, positioned precisely, and modified to create exactly the lighting effect you have in mind. When working with existing light, on the other hand, your choices are somewhat more limited. Since you will very rarely find perfect existing light on location, this means that you must learn to control and modify the light in order to produce a professionally lit portrait. This process begins with an understanding of the tools used to bounce and diffuse existing light, which are covered in this chapter—along with techniques for creating portraits with existing light only. The next step is augmenting the existing light with additional light sources, which will be covered in chapter 5.

Tools for Modifying Existing Light

Reflectors. Reflectors are devices used to bounce light into the shadow areas of a subject. A wide variety of reflectors are commercially available, including

Portable LiteDiscs from Photoflex are flexible reflectors that fold up into a compact shape for transport. They come in a variety of surfaces and sizes—and some are even reversible.

Lighting out of doors can be every bit as soft as diffused studio light. In this image entitled *Girl Next Door,* Don Emmerich has utilized soft directional daylight as a key light. A gold-foil reflector adds warmth to both sides of the face and lowers the lighting ratio to almost 2:1. The lighting pattern is barely perceptible, the light quality is so soft.

the kind that are collapsible and store in a small pouch. The surface of the reflector determines the quality of the reflected light. White reflectors provide soft, gentle fill, while silver- and gold-foil reflectors provide more light than white surfaces (so much that you can sometimes even overpower the ambient light, creating a pleasing and flattering lighting pattern). Gold reflectors also warm up the reflected light, making them ideal for working in shaded areas where a warm tone in the fill light is desirable. The size of the reflector should be fairly large; the larger it is the more effective it will be. (*Note:* Keep in mind that, many times, nature provides its own reflectors. Patches of sandy soil, a white floor, or a nearby building may supply all the fill-in you'll need.)

When using a reflector it should be placed slightly in front of the subject's face. Properly placed, the reflector picks up some of the main light and wraps it around onto the shadow side of the face, opening up detail even in even the deepest shadows. Be careful not to position the reflector beside the subject's face, where it may resemble a secondary light source coming from the oppo-

Keep in mind that, many times, nature provides its own reflectors.

The effects of a silver-foil-covered reflector are dramatically illustrated here. Note that the original image without a reflector is totally unusable (top left). With the Lastolite handheld Tri-Grip reflector from Bogen (right), the shadows are filled in without blowing out the highlights. The final image (top right) is a fine shot with plenty of detail in all the meaningful shadows. Because the Lastolite Tri-Grip is so easily configured, the fill light can be placed almost anywhere you desire.

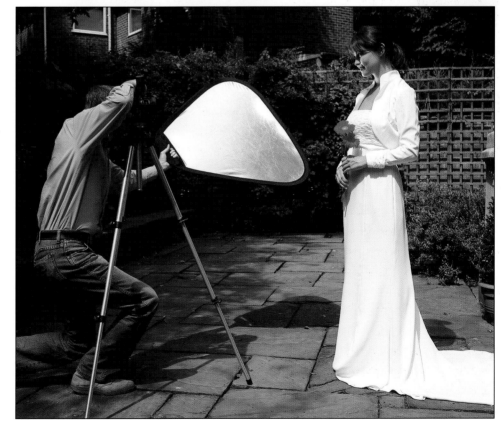

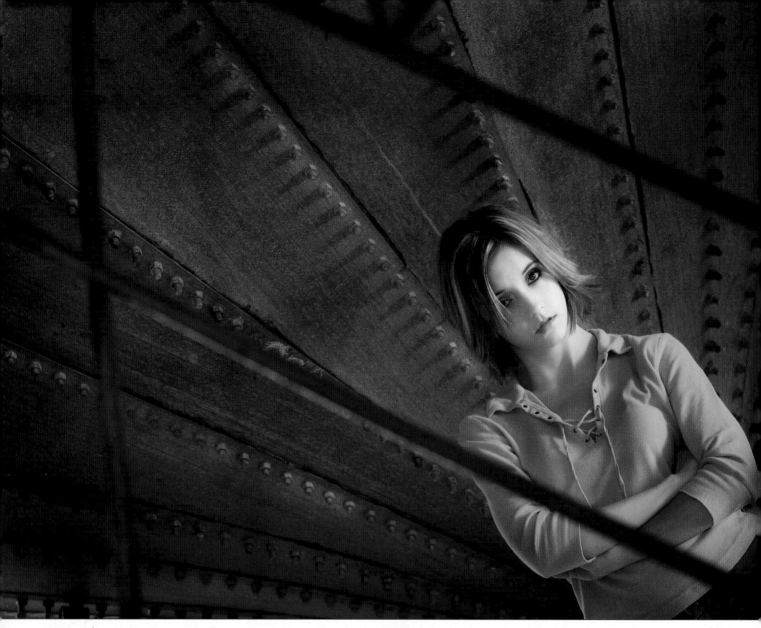

This senior portrait was shot on location outside under a grain bin used for soybeans. The image was taken on the shadow side of the grain bin. No direct sunlight was used. A 72-inch silver reflector was placed to the right of subject, about thirty feet away, to redirect the sunlight onto the subject's face. A second small reflector was placed just to the left side of the subject, outside of the frame, to brighten up the shadows. Notice the delicate edge light that the second reflector created along the subject's right arm and shoulder. Photograph by Craig Kienast.

site direction as the main light. Be careful about bouncing light in from beneath your subjects, as well; lighting coming from below the eye–nose axis is generally unflattering. Also note that reflecting bright sunlight onto the subject may make the subject uncomfortable and cause them to squint.

Achieving this correct positioning may require an assistant to set and adjust the reflector while the photographer evaluates the scene through the viewfinder. Photographer Brett Florens favors ambient light for his primary light source, so having an assistant work with a reflector becomes vitally important. Backlighting, "which lends a romantic feel," he says, is harnessed quite often (as is the setting sun with its dramatic lighting). The assistant's role is vital, Brett says. "An assistant is worth his or her weight in gold, and the finished product is all the better for having an assistant there."

In addition to the reflectors that are available commercially, many photographers opt to design their own devices. Fuzzy Duenkel, a master of outdoor and indoor existing light, tried every commercial reflector out there before deciding to build his own (which he calls the Fuzzyflector) based on an idea he heard at a lecture by photographer Bruce Hudson.

RIGHT—Brett Florens feels that an assistant is vital for location portraiture. In this groomsman's portrait, an assistant carefully positioned a reflector for fill.

BELOW—The light in this pleasing bridal portrait is exquisite. Direct sunlight bounces off a terracotta wall onto the bride and, at the same time, produces a column of wonderful low-angle light. The photographer, Parker J. Pfister, knowing a good thing when he sees one, decided to photograph the light and not the bride, making her a well placed component in his superbly balanced design. Because the light was intense and he didn't want everything razor sharp, Parker opted for a $^1/_{8000}$ second shutter speed at f/4.0 at ISO 200.

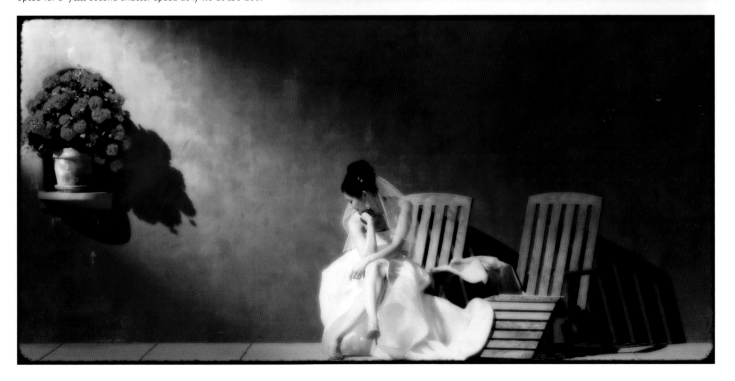

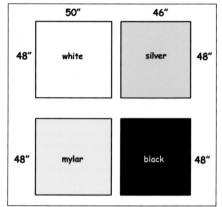

Here, the backlighting bounces into the Fuzzyflector to create the key light on her face and body. Since the Fuzzyflector stands only four feet tall, it is below the height of a standing subject. To counteract that, Fuzzy has the subject look down (lower their chin) to avoid producing "ghoul" lighting. Photograph by Fuzzy Duenkel.

	50"		46"	
48"	white		silver	48"
48"	mylar		black	48"

Diagram of Fuzzyflector.

The Fuzzyflector starts out as a 4x8-foot sheet of rigid, foil-covered foam insulation board. The board is cut into two rectangles, one measuring 46x48 and the other measuring 50x48 inches. When hinged with CPVC pipe, the uneven lengths of the two boards allow the unit to stand on its own. (*Note:* Fuzzy's original design used a duct-tape hinge, but he found this needed repairs too often.)

Each panel is then bordered with white gaffer's tape to protect the edges. The individual panels are then treated to provide a variety of reflective surfaces. One is spray-painted with a satin silver finish to provide a moderately

FACING PAGE—Even when the light is relatively good, as on this shady porch portrait, the Fuzzyflector can be used to create a well-defined lighting pattern. Photograph by Fuzzy Duenkel.

Sometimes the light bouncing off the Fuzzyflector (particularly the Mylar side) is so intense that Fuzzy will use a scrim between it and the model. This softens the light considerably. Photograph by Fuzzy Duenkel.

soft, neutral fill light; one panel is spray-painted matte white; one is spray-painted matte black (for use as a gobo; see page 56); and one panel is covered with mirrored Mylar (held in place with spray adhesive and edged with an additional layer of white gaffer's tape to secure the Mylar).

The array of reflectivity provided by the Fuzzyflector makes it ideal for virtually any outdoor or indoor lighting situation and Fuzzy says it fits neatly in his minivan. You can get full information on how to build it on Fuzzy's web site: www.duenkel.com. The design is part of a book that Fuzzy sells on his site called *FuzzyLogic*.

Mirrors. Like reflectors, mirrors are used to bounce light into a shadow area or to provide a reflected key light. Mirrors reflect a high percentage of the light that strikes them, so they can be used outdoors to channel backlight into a key light.

Scrims. A scrim is a white, translucent panel that is used to diffuse or direct light. Scrims are sold commercially and come in large sizes up to 6x8 feet or so. Like snap-up portable reflectors, these scrims are supported on a flexible frame that folds down to about a quarter of the scrim's extended size.

Positioned between the sun (or another light source) and the subject, a scrim basically works just like the diffuser in a softbox, softening the light that shines through it. In the movie business, huge scrims are suspended like sails on adjustable flats or frames and positioned between the sun (or a bank of lights) and the actors, diffusing the light on the entire area. In still photography, scrims are great when you want to photograph your subject in direct

Mirrors are used to bounce light into a shadow area or to provide a reflected key light.

Position the scrim between the light and the subject to soften the lighting.

sunlight. Simply position the scrim between the light source and the subject to soften and change the available lighting. The closer the scrim is to the subject, the softer the lighting effect will be.

Another use for scrims is in combination with a reflector. With backlit subjects, the scrim can be held above and behind the subjects and a simple reflector used as fill-in for soft outdoor lighting. The soft backlight causes a highlight rim around the subject, while the reflector, used close to the subject, provides a low light ratio and beautiful soft frontal lighting. This works best with head-and-shoulders portraits, since a smaller scrim close to the subject can be used.

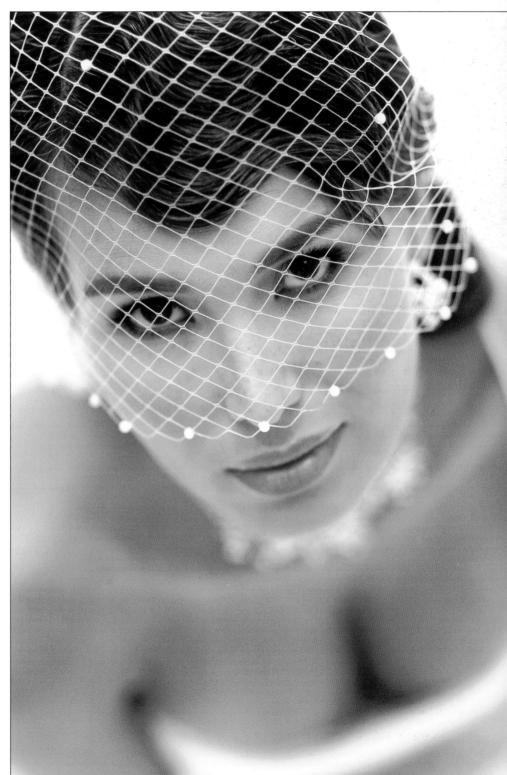

This is the kind of light a scrim produces when used to diffuse sunlight. It is open and completely diffused. The closer a scrim is to the subject, the softer the light becomes. Photograph by Joe Buissink.

Scrims can also be used in window frames to soften sunlight that enters the windows. Tucked inside the window frame, the scrim is invisible from the camera position. In outdoor situations, scrims can be very useful for evening out the effect of spotty light (light filtering through trees, for example).

Keep in mind that the scrim will lower the amount of light on the subject, so meter the scene with the device held in place. Also note that the quantity of light (particularly in outdoor applications) may be lower on your subject than on the background and the rest of the scene. As a result, the background may be somewhat overexposed—which is not necessarily an unflattering effect. To prevent the background from completely washing out, it helps to choose a dark- to medium-colored background.

Gobos. Gobos, or "black flags" as they're sometimes called, are lightweight opaque panels that are used as light blockers.

Gobos are used to create a shadow when the source of the main light is too large, with no natural obstruction to one side or the other of the subject. For example, there are occasions when the light is so diffuse that it provides no modeling of the facial features. In these cases, you can place a black card or flat close to the subject. The effect of this is to subtract light from the side of the subject on which it is used, effectively creating a stronger lighting ratio to better show depth and roundness.

On location shoots, gobos are often used to block overhead light when no natural obstruction exists. If you find a nice location for your portrait but the

DeEtte Sallee noticed that the frosted glass awning above the entranceway to this hotel diffused the direct afternoon sunlight, creating a beautiful overhead softbox during the middle of the day. DeEtte moved in close with a Nikon D100 and 10.5mm f/2.8G ED AF DX Fisheye-Nikkor lens and exposed the scene for $^1/_{750}$ second at f/2.8.

Lite Panels from Photoflex are translucent, reflective flexible panels that can be combined to create any kind of lighting on a set or on location. While the photo shows these scrims as studio accessories, they are easily used in the field to diffuse direct light.

You may have to shoot at a slower shutter speed or wider lens aperture than anticipated.

light is too overhead in nature (creating corresponding dark eye sockets and unpleasant shadows under the nose and chin), you can use a gobo directly over the subject's head to block the overhead illumination. The light that strikes the subject from either side will then become the dominant light source. This is exactly like finding a porch or clearing to block the overhead light (see page 79).

There are two drawbacks to using an overhead card. First, you will need to have at least one assistant along to hold the card in place over the subject. Second, using the overhead card lowers the overall light level, meaning that you may have to shoot at a slower shutter speed or wider lens aperture than anticipated.

One way to deal with overhead light is to introduce a gobo that prevents the overhead light from striking the subjects and allows soft light to come in from the side, creating a pleasing lighting pattern and lighting ratio. Here, Charles Maring, accomplished just that by giving the couple a black umbrella as a prop. Examine the highlight on the umbrella and you can see that the light, even though diffused, is almost directly overhead.

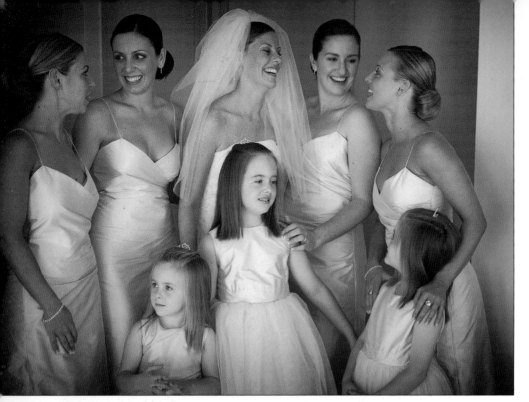

LEFT—Marcus Bell is a maestro at capturing the essential moment of a scene, especially with small groups of people. Here, the lighting is relatively even, thanks to reflected daylight from a large hotel room bay window. It is dim, however, and even with an increased ISO of 800, he still picks up a little subject movement. However, the great expressions more than make up for the challenging light level.

BELOW—Window light is elegant and powerful. Here, soft window light creates the lighting pattern on the couple, while direct sunlight spills across the floor, providing a natural fill in to the frontal planes of the faces. Photo by Kevin Jairaj.

Window light can be every bit as beautiful as studio light—in fact, it can sometimes be more desirable. Here, Jeff and Julia Woods positioned their bride far enough from a large window to create a full-length portrait. The farther you move your subject from the window, the more the light falls off (loses intensity) and the more contrast there will be on the subject. Here, the lighting is soft and forgiving—just a little contrasty—and required no fill-in. The exposure was $\frac{1}{40}$ second at f/2.8 at ISO 800.

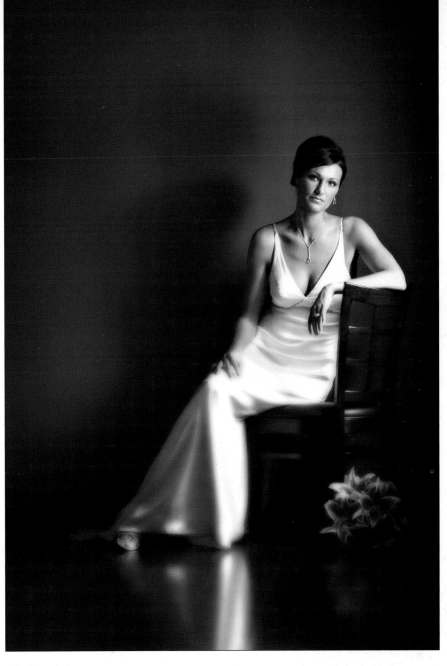

This allows for a great variety of moods in a single shooting session.

Window Light

One of the most flattering types of existing light you can use is window lighting. It is a soft light that minimizes facial imperfections. Additionally, the light flows in only one direction and (usually) from only one source. It is almost always diffused, as well. Window light is usually fairly bright and it is infinitely variable, changing almost by the minute. This allows for a great variety of moods in a single shooting session.

Challenges. Despite its beauty, window lighting presents several notable challenges. Since daylight falls off rapidly once it enters a window, it is much weaker several feet from the window than it is close to the window. Therefore, great care must be taken in determining exposure, especially in group portraits. Another problem, common when shooting in buildings that are not designed for photography, is that you may encounter distracting backgrounds, uncomfortably close shooting distances, and a corresponding need to shoot with wide-angle lenses.

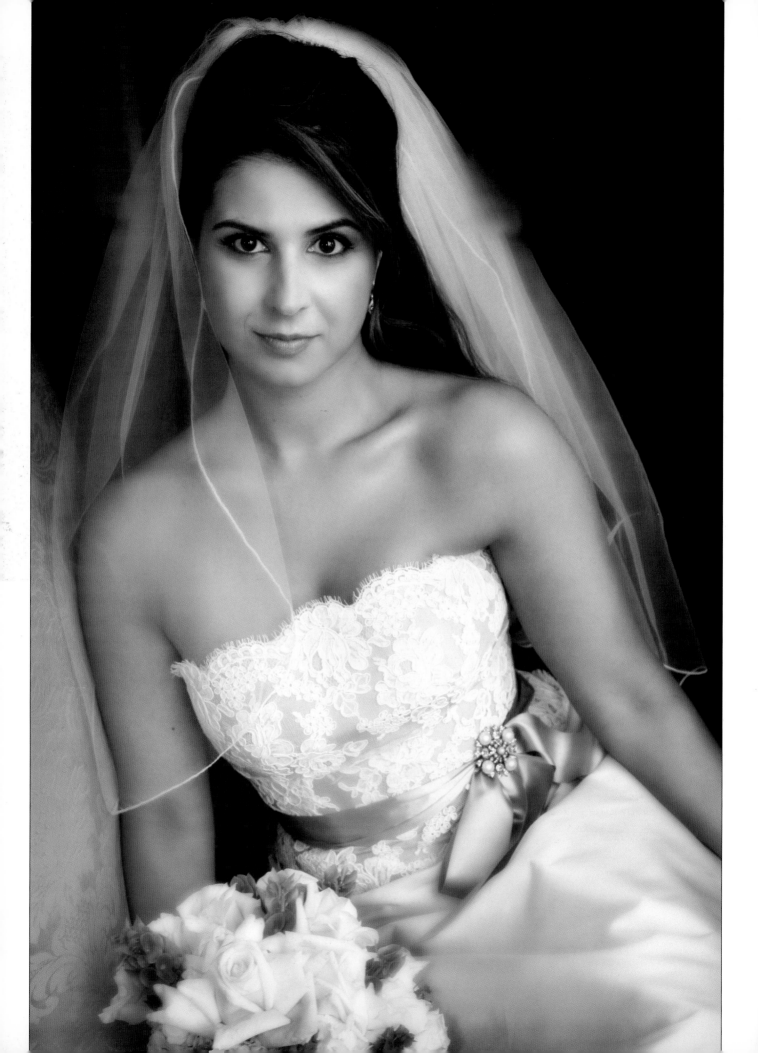

FACING PAGE—Scott Robert Lim created this beautiful window-lit portrait by placing his bride in front of a very large window. According to Scott, "It was near the end of day and all the windows were facing east, so I tried to find the largest natural light source on the east side. I was standing to the left and I think my body blocked part of the light, which accounts for the lighting ratio and the smaller catchlight in her right eye."

ABOVE—The Spanish-style portico is like window lighting on steroids. You get the benefits of intensity, directionality and softness, without the need for long shutter speeds. Here, Bruce Dorn took advantage of light quality and intensity to create an action portrait that is truly priceless. He further worked the image in Painter and Photoshop to create a genuine work of art.

Direction and Time of Day. The best quality of window light is found at mid-morning or mid-afternoon. Direct sunlight is difficult to work with because of its intensity and because it often creates shadows of the individual windowpanes on the subject. It is often said that north light is the best for window-lit portraits, but this is not necessarily true. Good quality light can be had from a window facing any direction, provided the light is soft.

Subject Placement. One of the most difficult aspects of shooting window-light portraits is positioning your subject so that there is good facial modeling. If the subject is placed parallel to the window (with the window squarely to one side of their face), you will get a form of split lighting that can be harsh and may not be right for certain faces. It is best to position your subject away from the window slightly so that he or she can look back toward it. In this position, the lighting will highlight more areas of the face.

The closer to the window your subject is positioned, the harsher the lighting will be. The light becomes more diffused the farther you move from the window, as the light mixes with other existing light in the room. Usually, it is best to position the subjects three to five feet from a large window. This not only gives better lighting, it also gives you a little extra working room to produce a flattering pose and pleasing composition with a well-organized back-

ABOVE—This is a remarkable mixed-light photograph of the bride and her bridesmaids taken in a hotel lobby by Al Gordon. Out of view to the right are long floor-to-ceiling windows that let in beautiful, soft light. One window, in particular, lit the area where the bride stood. The rest of the lighting is a mixture of room light from the lobby's candelabras and chandeliers. Even though the photographer had a softbox and strobe by his side, he never needed to use it because of the beautiful existing light.

RIGHT—There is no more serious business at a wedding than the last-minute preparations by the bridesmaids and flower girls. Photographer Kevin Jairaj captured this priceless scene with window light only. The light is a bit contrasty, as the foursome was a good distance from the window. Curtains blocked the light from reaching the back of the room, making that area of the scene go dark. The image was made with a Canon EOS 5D and EF 70–200mm f/2.8L IS USM zoom lens at an exposure of ¹/₁₈₀ second at f/2.8 at ISO 1250.

ground. Don't be afraid to use a wide-angle lens or wide-angle zoom in such situations. Just remember to keep your subjects well centered to avoid distortion at the frame edges.

Metering. With window light, the best way to meter for exposure is with a handheld incident meter. Hold it in front of the subject's face, in the same light as the subject, and take a reading with the light-sensitive hemisphere pointed directly at the camera lens. (*Note:* If you are working with more than one subject, keep in mind that you'll get multiple readings as you meter each face. To best balance this, choose an exposure midway between the readings.)

If using a reflected meter, like the in-camera meter, move in close and take readings off the faces. Most in-camera light meters take an averaged reading, so if you move in close on a person with an average skin tone, the meter will read the face, hair, and what little clothing and background it can see and give you a fairly good exposure reading. If the subject has a particularly fair

TOP LEFT—Pure window light can be nearly perfect and totally exhilarating. Kersti Malvre made this Christmas eve image late in the day with the child peering out a window to see if Santa was on his way. Kersti subdued the light around the window in Photoshop, so that the light on the child focused all of the visual interest on him. She also brought up the intensity of the background Christmas lights so that they set the scene.

TOP RIGHT—This picture was created using available light from a hotel window and tungsten light from a nearby lamp. Photographer Dan Doke removed the lampshade and placed the lamp behind the bride.

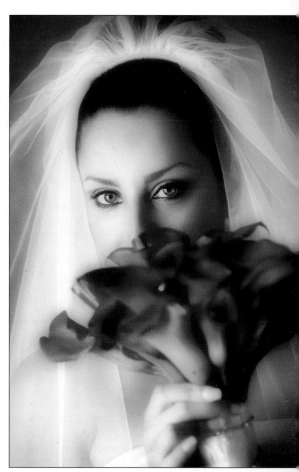

Then he moved the subject away from the window until the tungsten light and the available light were the same intensity. He exposed for the light coming in through the window, knowing that the backlight would create a warm glow with a vignette. In Photoshop, Dan added contrast and tweaked the colors slightly using Color Balance. He also added a vignette, brightened the eyes, and added Gaussian Blur for a softening effect to the overall picture.

BELOW—When it comes to existing light, photographer David Beckstead knows that you have to play the hand you're dealt. Here, window light provided enough illumination for David to capture this priceless and uninterrupted moment between the bride and groom. The image was made at $^1/_{180}$ second at f/2.8 at ISO 800.

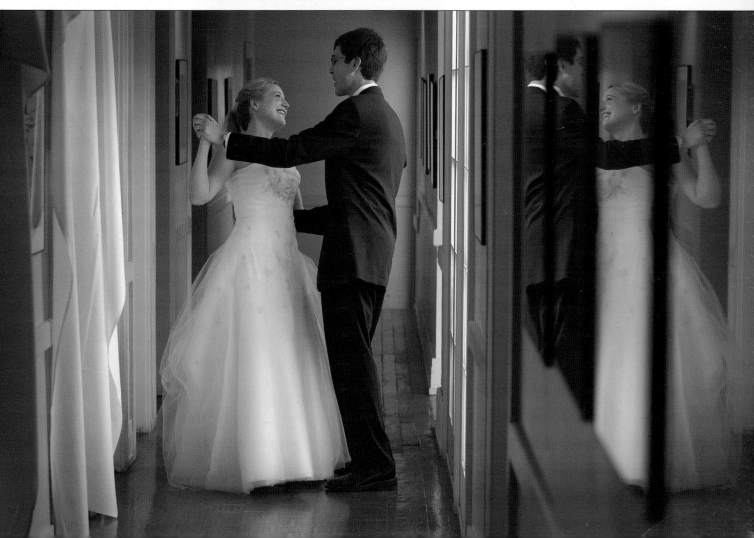

or dark complexion, remember to adjust your exposure up or down to render the skin tones accurately; a one-stop adjustment is usually sufficient.

Fill Light. The easiest way to fill the shadows in window-light situations is with a large white or silver fill reflector placed next to the subject on the side opposite the window. This should be angled up to catch incoming light and reflect it back onto the subject. Setting the proper angle takes some practice and is best handled by an assistant so that you can observe the effects in the viewfinder.

If a reflector does not provide sufficient fill light, it may be necessary to provide another source of illumination to achieve good balance. Sometimes, flicking on a few room lights will produce good overall fill-in by raising the ambient light level. If you do this, however, be sure the lights do not overpower the window light, creating multiple lighting patterns. Keep in mind that you will get a warm glow from the tungsten room lights if you are using daylight-balanced film or a daylight white-balance setting. This is quite pleasing if it's not too intense.

Having a room light on in the background behind the subjects also helps to open up an otherwise dark background, providing better depth in the portrait. If possible, position the background room light out of view of the camera—behind the subject or off to the side—so it lights the wall behind the subject.

If neither reflected light nor room light is available (or sufficient), use bounce flash. You can bounce the light from a portable electronic flash off a white card, the ceiling, an umbrella, or a far wall—but be sure that it is at least half a f-stop less intense than the daylight reading from the window light.

It may be necessary to provide another source of illumination to achieve good balance.

FACING PAGE—Window light provided the key light, but the room lights provided the rich warmth and peach tones throughout this wonderful bridal portrait. It is a balancing act; when you have daylight and room light and they need to work in harmony. Photographer Tom Muñoz used the room lights to boost the fill level and warm the color to his liking.

BELOW—Tibor Imely says of this shot, "It all happened really quickly. Everyone was waiting for the bride and groom to enter the reception for the introduction. I looked behind me and three feet away were these three little girls with their arms around each other. When I aimed the camera at them they came up with these incredible expressions. I made only one shot." The image was made with a Canon EOS 10D, 16–35mm f/2.8 zoom, and bounce flash.

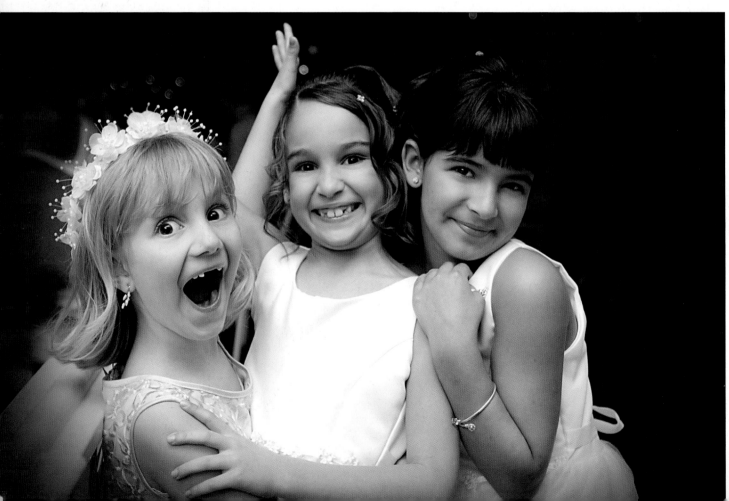

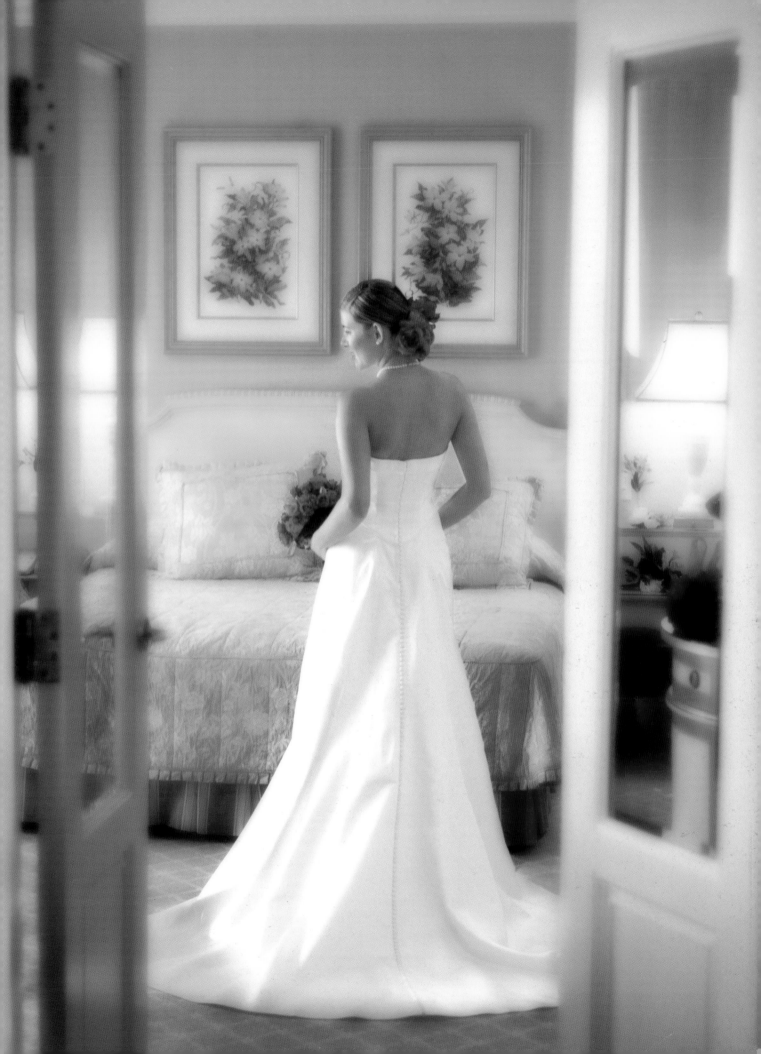

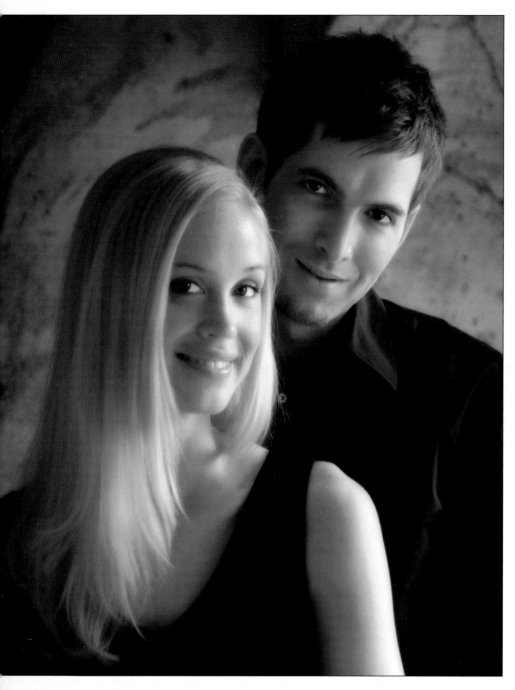

Kevin Jairaj says the lighting is not tricky for this shot, but finding good lighting like this is. The image was shot in an outdoor hallway with light coming in from camera right. According to Kevin, "It was really dark in the hallway except for the nice light coming in. I used just a touch of fill-flash to get some sparkle in the eyes." The photo was shot in RAW mode with a Canon 20D and 70–200mm IS L lens at 130mm. The exposure was $\frac{1}{20}$ second at f/2.8 at ISO 100. The shot is warm toned because Kevin used a "cloudy" white balance setting to warm the image.

When using flash for fill-in, it is important to carry a digital flashmeter to determine the intensity of the flash.

Custom White Balance. Since most window-light situations will entail a mix of daylight and room light, a custom white-balance reading should be taken when shooting digitally. If working in changing light, take a new custom white-balance reading every twenty minutes or so to ensure that the changing light does not affect the color balance of your scene. Alternatively, you can shoot in RAW capture mode, which will allow you to fine-tune the color balance after capture.

Diffusing Window Light. If you find a nice location for a portrait but the light coming through the windows is direct sunlight, you can soften it by taping a scrim inside the window frame. Light diffused in this manner has the

Take a new custom white-balance reading every twenty minutes or so.

feeling of warm sunlight but without the harsh shadows. If it's still too harsh, try doubling the thickness of the scrim. Daylight that is diffused in this way is so scattered that you will usually not need a fill source. Even without fill, it is not unusual to have a low lighting ratio in the 2:1 to 2.5:1 range. (*Note:* The exception is when you are creating a group portrait with a large number of people. In that case, you should use reflectors to bounce light back into the faces of those farthest from the window.)

Room Light (and Other Man-Made Sources)

In addition to window light, many incredible portraits are made using the existing light from man-made sources, such as room lights, lights on the dance floor at a wedding, or even street lights. Keep in mind when using these sources that long exposures may be required; few man-made lights are as intense as photographic flash. As such, shooting from a tripod or using an image-stabilization lens is a good idea just to ensure critical sharpness. It's also important to note that using man-made existing-light sources often results in portraits that are not "traditionally" lit—but don't let that dissuade

One of the best types of window light is from two windows facing different directions. Here, Marcus Bell availed himself of the great and abundant window light in the upstairs bedroom of the bride's house—light that was diffused by sheer curtains on the windows. He made the exposure at $^1/_{80}$ second at f/2.8 at ISO 400 with a 24–70mm f/2.8 lens at its 24mm setting.

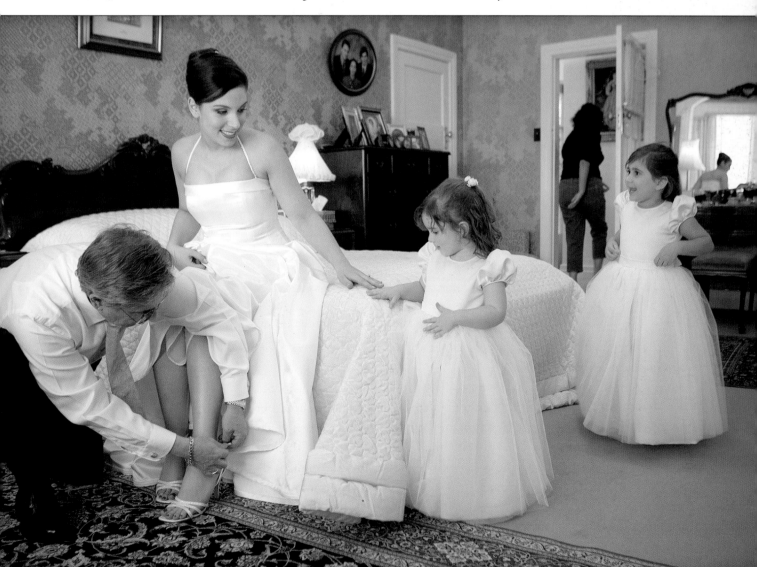

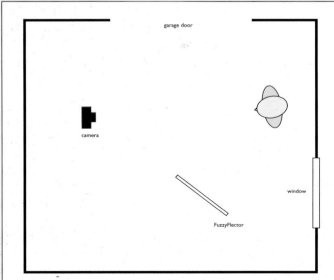

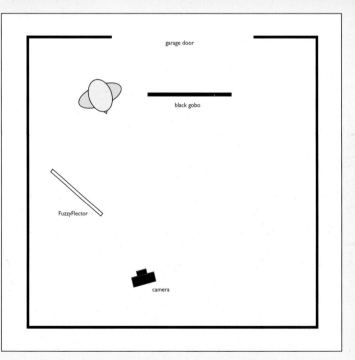

Here are two examples of senior portraits done by Fuzzy Duenkel with garage light. Fuzzy is harnessing only available light, but because he uses such high-efficiency reflectors as his homemade Mylar Fuzzyflector, the light looks like studio lighting. Refer to the accompanying diagrams and see if you can follow the path of the main and secondary light sources. Here are a few hints: the main light—the open garage door or large window—produces an edge highlight around the perimeter of the subject. The main light is usually a backlight.

FUZZY DUENKEL'S GARAGE LIGHT

Fuzzy Duenkel photographs high-school seniors in the their homes and sometimes in the family garage, where super-sized openings often allow soft light to enter the room. One technique he developed is to use light from an open garage door to completely surround the top and sides of the subject. He then uses a reflector to create a low main light. Fuzzy says, the effect creates "dramatic close-up images that are well suited for sports or other themes—and for masculine guys with their shirts off." This style has been a huge success for Fuzzy's studio. Although the effect can be created in the studio, he prefers to use their garages because, "I get the reaction of, 'Wow, you did this in my *garage*?'"

Depending on which way the subject's head is turned, you can choose either broad or short lighting. Fuzzy cautions, "Be aware that sunlight may be striking a driveway outside. That bright, low light may adversely affect the light direction and pattern on your subject. If so,

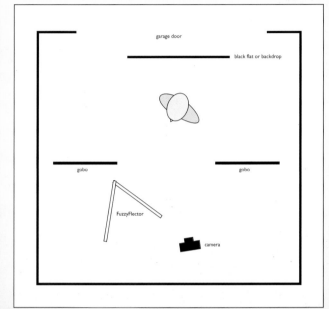

block it with a low, black gobo." He also advises to look for a window that can be used as an accent light. If one exists, position the subject to use it for a hair, edge, or separation light.

Fuzzy uses his homemade Fuzzyflector plus a gobo for almost all of his garage portraits. The gobo is useful to prevent flare when such a large light source is backlighting the subject. The Fuzzyflector (see page 50) allows him to vary the amount of reflected fill light and, because the device is mobile and easily reconfigured, he can precisely position it for the right angle of reflectivity. He tends to use the Fuzzyflector at low angles for strong reflected light from a low angle, which he says is very effective for guys.

This setup is more complicated and difficult, but very interesting because of the edge light that completely surrounds the subject. Fuzzy used a black Larsen Reflectasol as the background because he wanted an unidentifiable background. If you prefer, you can use a dark, opaque, or painted background. Two gobos were necessary to prevent flare from the strong backlight. The ideal location for a gobo is usually next to the subject, but the gobo on the side of the Fuzzyflector needs to be behind it (nearer to the camera) so outside light isn't blocked from hitting the Fuzzyflector.

you from shooting when the light is less than perfect. As the portraits in this section show, lighting that defies convention is often extremely appealing.

"Can" Lights. Australian photographer Yervant is renowned for his ability to find interesting existing light sources on location.

One of his most widely recognized shots (see facing page) was actually created using the overhead "can" lights in an underground parking garage. Short on time, Yervant realized he had not done any formal bridal portraits on the wedding day, and coaxed the bride down to the parking garage for a few shots. To make use of the lighting directly overhead, he had her throw her head back in laughter so that the light would fill her face instead of obscuring her eyes in shadow. This shot illustrates not only the resourcefulness of the wedding photographer on location, but also the ability to see light and recognize a prime location.

Yervant's success with "can" lighting was hardly a one-shot deal. In the image shown below, he had the bride stop under a hotel's overhead light; a spot that blasted a small area of the wall and carpet with a sharp, hot light. He positioned the bride so that the single light would reveal her shape and had

FACING PAGE—This is a classic and award-winning shot by master wedding photographer, Yervant. It was done not using studio strobes, but an overhead "can" light in an underground parking garage.

BELOW—Light is where you find it and what you make of it. Here, Yervant used an overhead "can" light—hardly what most photographers consider ideal—to create an extremely dramatic image.

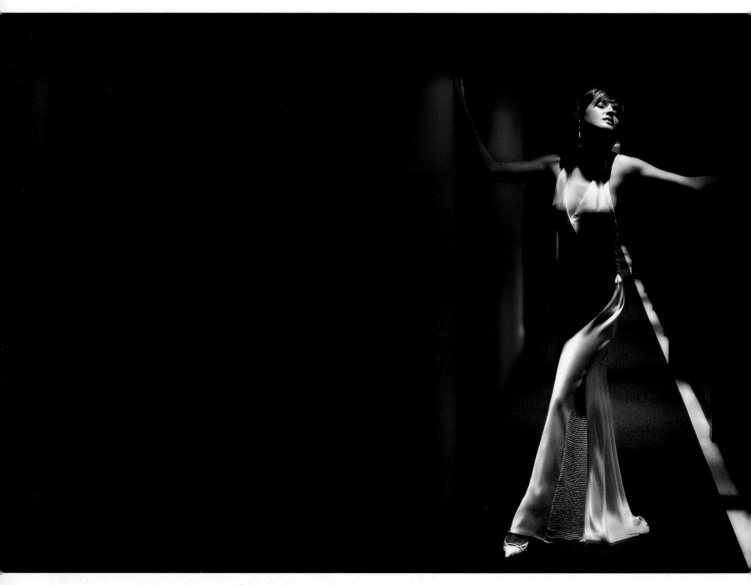

her glance up into the light to create highlights on the frontal planes of her face. She liked it so much that it ran over two pages in her wedding album.

Exterior Lights. Sometimes great directional lighting is right in front of you—regardless of the time of day or night. Photographer Kevin Jairaj recalls the setting for one of his most memorable images (see image below). "I discovered a spot-lit wall," he says. "I wanted the bride's face to be highlighted by the beam of light, so I had her stand with her back against the wall with her face tilted upwards towards the light. The reason this shot was successful was because I used all existing light and a long exposure with my camera on a tripod to capture the moment. I really wanted to try something a bit more dramatic and edgy to match the ambiance of the location." It's proof that with refined powers of observation, you can find great existing light in some unexpected locations.

Play the Hand You're Dealt. In any given situation, there is a limited amount of existing light. If you spend too much time trying to tease out just the right quality—especially when shooting wedding photography—you may find you've missed countless wonderful moments. As photographer David Beckstead says, "You are given only what the weather and bride's timeline allows. Part of being perceptive is learning how you change and flow with what

FACING PAGE—The can lighting found in many hotels and other public buildings is sharp and overhead. It is often used as an accent light to light walls or alcoves. Many photographers employ such available light, but the caveat is that the subject must look up toward the light to avoid the "raccoon eyes" look of overhead lighting. Kevin Jairaj made this image with a Canon EOS 5D and EF 20mm f/2.8 USM lens at 1/8 second at f/2.8 at ISO 640. Notice the bride looking up so that her face is well lit by the can light above.

BELOW—Kevin Jairaj was finishing up a session late in the evening when he happened to see this wonderful directional beam. He persuaded the bride to take a few shots in this spot.

really happens at your wedding, hour after hour. The 'perfect' light will often elude you, so it's best to make use of the harsh light, the bad light, and the poor-quality light—and then pull out all the stops of perception by working these types of light to your advantage. It's all in your head!" he says.

So how do you quickly determine what is there and how to utilize it to the best of your abilities? David Beckstead says he walks into the room and squints his eyes so that all the complexity of the colors and textures fades away to nothing but darks and lights. He then opens his eyes widely and goes to the light, looking to see if this natural light can be used as a line, leading to his subjects (for a creative effect), then backing off to see how the light can be used in a broader overall composition. Once he has digested this information, he goes ahead with his first "safe" shot, as he calls it, often using the natural light. He can then utilize the time between other upcoming "safe" shots to experiment with other artistic interpretations. This strategy helps David

BELOW, LEFT AND RIGHT—David Beckstead loves natural light and has attuned himself to its many uses by analyzing a scene to see the full potential of the light source. He prefers back- and side-lighting, but knows that the hallmark of a real professional is being able to create an amazing portrait using whatever light he's dealt.

ABOVE—This is a group portrait that pushes the limits of the light. Bars are notorious for being dimly lit. Here, Kevin Jairaj photographed the bridal party using room light and bounce flash at an exposure of $1/30$ second at f/4 with a Canon EOS 5D and EF 16–35mm f/2.8L USM zoom lens at ISO 1250. He had to lower the base exposure to record the room lights, a technique known as "dragging the shutter." He chose f/4 rather than f/2.8, the lens's maximum aperture, to control some of the aberrations and sharpness problems that occur with fisheye lenses used wide open.

LEFT—Fuzzy Duenkel is a master of any lighting situation. Here, on a front porch, he masterfully redirects the sunlight onto his subject, making it look as though she was photographed in a studio with a full complement of lights.

avoid a common tendency among photographers to go directly to the subject and start shooting without taking a moment to see all the possibilities.

Outdoor Lighting

Nature provides every lighting variation imaginable—that's why so many images are made with it. Often, the light is so good that there is just no improving on it.

For example, I used to work for a major West Coast publishing company that specialized in automotive magazines. One of the studios we used for photographing cars was massive, with a ceiling that was between three and four stories high. Below the ceiling was a giant scrim suspended on cables so that each of the four corners could be lowered or raised independently. Enormous banks of incandescent lights were bounced into the scrim to produce a huge milky-white highlight the length of the car—a trademark of automotive photography. Despite the availability of this space, if time and the weather were on their side, the staff photographers would invariably opt to photo-

graph the car at twilight, when the setting sun, minutes after sunset, creates a massive skylight in the Western sky. No matter how big or well equipped the studio, nature's light is far superior in both quantity and quality (although it fades rather quickly).

In order to harness the power of natural light, one must be aware of its various personalities. Unlike the studio, where you can set the lights

BELOW—Learning to see light is a skill that good photographers acquire over time. In this beautiful image by Jeffrey and Julia Woods, the light is diffused backlight from a late-afternoon sky with scattered clouds. The Woods positioned the couple so that the groom's face received the reflected light from the bride and her white dress, both natural reflectors. The lighting ratio is a beautiful a 2.5:1. The image was made with a Canon EOS 1D Mark II and 70–200mm f/2.8 lens at 200mm. The film speed was ISO 160 and the exposure was $\frac{1}{1000}$ second at f/3.2.

RIGHT—Marc Weisberg employed a tent overhang to block the overhead afternoon light, which then filtered in from the sides, front, and back. Notice the specular highlights on the right side of the bride's face caused by intense reflections coming from that direction (probably off of a building). The light is plentiful and frontal in nature—and because of the tight cropping used, the exposure could be biased exclusively for the faces, letting the background burn out.

FACING PAGE—A beautiful scene paired with the light at the edge of a clearing to make this Drake Busath portrait an award-winner. To lend some sparkle to the light, Drake used a large reflector below the children and one above the camera lens, held by an assistant.

to obtain any effect you want, in nature you must use the light that you find or find ways to modify it to suit your needs.

Avoid Direct Sunlight. By far the best place to make outdoor images is away from direct sunlight. Look for a clearing in the woods, where the trees block the overhead light from hitting the subject. From the clearing to the side, diffused light will filter in, producing better modeling on the face than in an open area (where the light is overhead in nature and leaves deep shadows in the eye sockets and under the nose and chin of the subjects).

Kevin Jairaj, who makes it a habit to look for good directional lighting, recommends looking for an outdoor portico, where light from above is blocked by a roofline or other architectural elements. This allows soft directional light to spill in from the sides, usually through open columns that provide beautiful compositional elements. Depending on how you position your

Diffused light will filter in, producing better modeling on the face than in an open area.

In this image, the couple was positioned facing the soft light coming into the portico. It's as if a large softbox was positioned nearby to provide elegant portrait lighting. Photo by Kevin Jairaj.

ABOVE—Direct sunlight is not a good choice for a main light in portraiture. Here, however, Heidi Mauracher used it effectively and eliminated the problem of the bride squinting by outfitting her in sunglasses. Heidi eliminated the background and foreground completely in Photoshop to make this a really unusual image.

LEFT—In the manicured gardens of a Scottish castle, Dennis Orchard found the daylight to his liking. Walking along a tree-covered path, Dennis saw that the light on his bride and groom was coming in from the sides (blocked overhead by the trees), creating a directional, pleasing lighting pattern.

subjects in relation to this directional light, it can be frontal or side-lighting—but it always has a singular and well-defined source point. Kevin says, "When outdoors, I love shooting under awnings or building tops where I am able to see the light coming in from one side. I normally place the bride so that her face is turned into the directional light producing soft Rembrandt lighting on her face."

Working at Midday. Working at midday is a necessity for wedding photographers, as most ceremonies are during the middle of the day.

The best system if working at midday is to work in shade exclusively. Try to find locations where the background has sunlight on dark foliage and where the difference between the background exposure and the subject exposure is not too great—no more than 2.5 stops.

It is often impossible to avoid photographing out in the open sunlight on wedding days. In this case, the best strategy is to use the sun as a backlight and bias the exposure towards the shadow side(s) of the subject(s). This is where it's advisable to bring along an assistant who can flash a reflector into the shadow side of your couple to fill in the effects of the backlighting. A reflector is most effective when held below waist height and angled to bounce

It is often impossible to avoid photographing out in the open sunlight on wedding days.

This is the classic Southern California wedding portrait, complete with the kelp necklace on the surfer groom. The light is exquisite because of the buildings to either side blocking the overhead light. The color coordination is also perfect. Photograph by Mark Weisberg.

Midday light doesn't have to be harsh, especially where tall buildings block the direct light. The lighting is, however, still overhead in such situations. Knowing this helped Mike Colón, who waited until the bride's head was raised, taking advantage of the soft overhead light. Mike also used a radical new telephoto lens, Nikon's 200mm f/2.0, which cuts scene contrast and lighting contrast. This photo was made with a Nikon D2X and Nikon's AF-S 200mm f/2G ED-IF VR telephoto lens, set at $^1/_{1000}$ second at f/2.

Moving the reflector around will give you an idea of where to position it.

the overhead backlight back up onto the subject. Moving the reflector around and up and down will give you an idea of how much light it can reflect and where to position it. In bright situations, use a white reflector, so as not to overpower the natural light. In very soft light, use a gold or silver reflector for increased efficiency.

It is important to check the background while composing a portrait in direct sunlight. Since there is considerably more light than in a portrait made in the shade, the tendency is to use an average shutter speed like $^1/_{250}$ second

with a smaller-than-usual aperture like f/11. Small apertures will sharpen the background and distract from your subject. Preview the depth of field to analyze the background. Use a faster shutter speed and wider lens aperture to minimize background effects in these situations. The faster shutter speeds may also make it impossible to use flash, so have reflectors at the ready.

Low-Angle Sunlight. If the sun is low in the sky, you can use cross lighting to get good modeling on your subject. To do this, simply turn your subject into the light so as not to create deep shadows along laugh lines and in eye sockets. (*Note:* If photographing a group, be sure to position your sub-

LEFT—The late afternoon sky can sometimes act like a huge softbox, creating shadowless light with a frontal direction. Such is the case here in an engagement portrait made by Joe Photo. Joe also used a telephoto lens, which reduced the overall scene contrast slightly.

BOTTOM—This is a good example of the quality of light at or near sunset. The sun backlights the bride and groom, casting long, elegant shadows across the meadow grasses. Yet there is plenty of frontal fill to keep from silhouetting the couple. The fill is caused by the sun striking the clouds and sky opposite the setting sun at an angle close to the horizon. This is the twilight effect. Marcus Bell had to bias the exposure perfectly and do extensive burning-in in Photoshop to bring out the rich colors of the sky, yet hold detail and subtle tones in the grasses and nearby flowers.

jects so that one person's head doesn't block the light from striking the face of the person next to him or her.)

In this scenario, there must be adequate fill-in from the shadow side of camera to ensure that the shadows don't go dead. This is often done using a flash set to about a stop less than the daylight exposure. Of course, a reflector can also be employed (and carefully placed) to bounce the direct sunlight back into the shadow side of the face. Again, it's always best to use an assistant in this situation.

The problem in working with this light is that twilight does not produce catchlights.

After Sunset. As many of the great photographs in this book illustrate, the best time of day for making great pictures is just after the sun has set. At this time, the sky becomes a huge softbox and the effect of the lighting on your subjects is soft and even, with no harsh shadows.

There are, however, two problems with working with this great light. First, it's dim. You will need to use medium to fast ISOs combined with slow shutter speeds. In these situations, selecting an image-stabilization lens will expand your options by allowing you to handhold at extremely slow shutter speeds like ¼ or ⅛ second.

The second problem in working with this light is that twilight does not produce catchlights, the white specular highlights in the eyes of the subjects that make them sparkle with life. For this reason, most photographers aug-

ment the twilight with flash, either barebulb or softbox-mounted. The flash can be up to two stops less in intensity than the skylight and still produce good eye fill-in and bright catchlights.

Controlling the Background. For a portrait made in the shade, the best type of background is monochromatic. If the background is all the same color, the subjects will stand out from it. Problems arise when there are patches of sunlight in the background. To minimize these, you can shoot at a wide lens aperture and use the shallow depth of field to blur out the background. When working outdoors, some photographers also control the background by placing more space between it and the subject, throwing the background further out of focus.

Another way to minimize a distracting background is in postproduction retouching and printing. By burning-in or diffusing the background, you can make it darker, softer, or otherwise less noticeable. This technique is really simple in Photoshop, since it's fairly easy to select the subjects, invert the se-

For a portrait made in the shade, the best type of background is monochromatic.

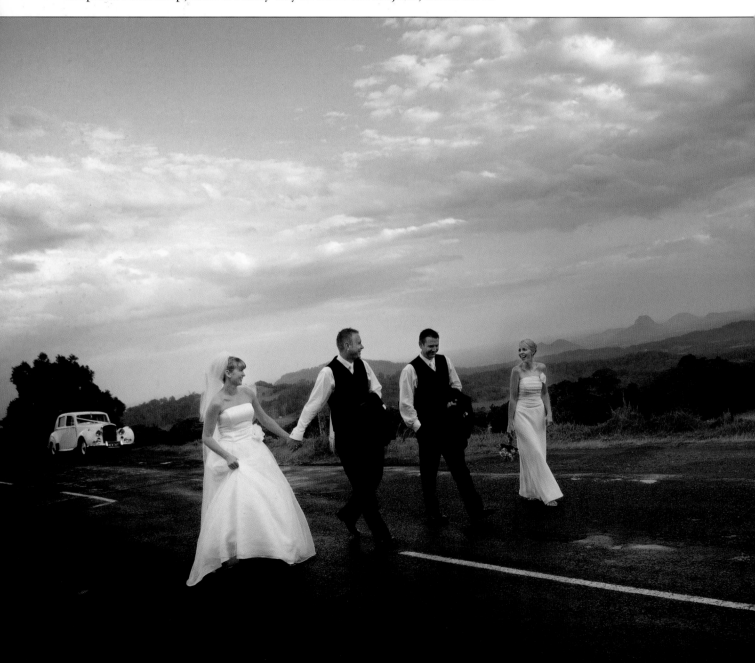

RIGHT—Mark Cafiero minimized a potentially distracting background by shooting at his zoom lens's widest aperture of f/3.5, which blended the highlights and shadows into an out-of-focus jumble of tones that lets the viewer focus solely on the bride. He also used out-of-focus foreground elements to isolate the bride.

BELOW—Working at twilight or near twilight lets you take advantage of the low angle of the diffused skylight, which paints the subjects with soft directional light. The trick is to not let the light intensity drop too much or you lose the ability to freeze subject action at a reasonable shutter speed. Here, Marcus Bell photographed this late-afternoon bridal party getaway with a very wide-angle lens so he could include the beautiful sky and locale.

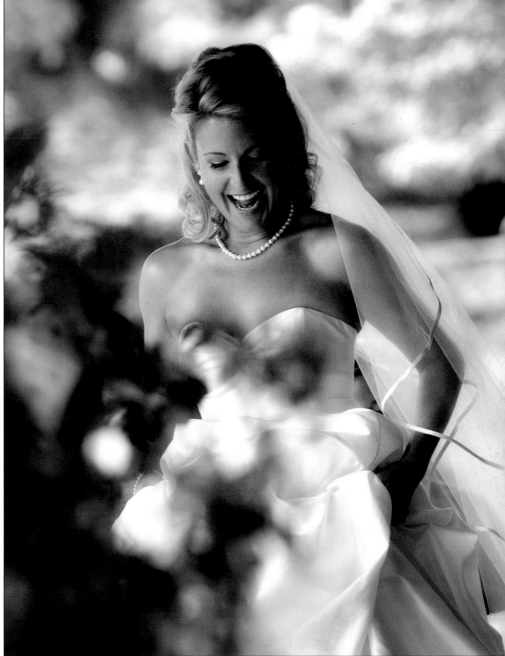

lection so that the background is selected, and perform all sorts of manipulations on it. You can also add a vignette of any color to visually subdue the background.

On outdoor shoots in particular, one thing you must especially watch out for is subject separation from the background. A dark-haired subject against a dark-green forest background will not separate, creating a tonal merger. Adding a back-side or edge reflector to kick some light onto the hair would be a logical solution to such a problem.

Cool Skin Tones. If your subject is standing in a grove of trees surrounded by foliage, there is a good chance green (or cyan from the open sky) will be reflected onto their skin tones. This can be hard to detect, since your eyes will adjust to the off-color rendering. The best strategy is to check the coloration in the shadow areas of the face. If the color of the light is neutral, you will see gray in the shadows; if not, you will see either green or cyan.

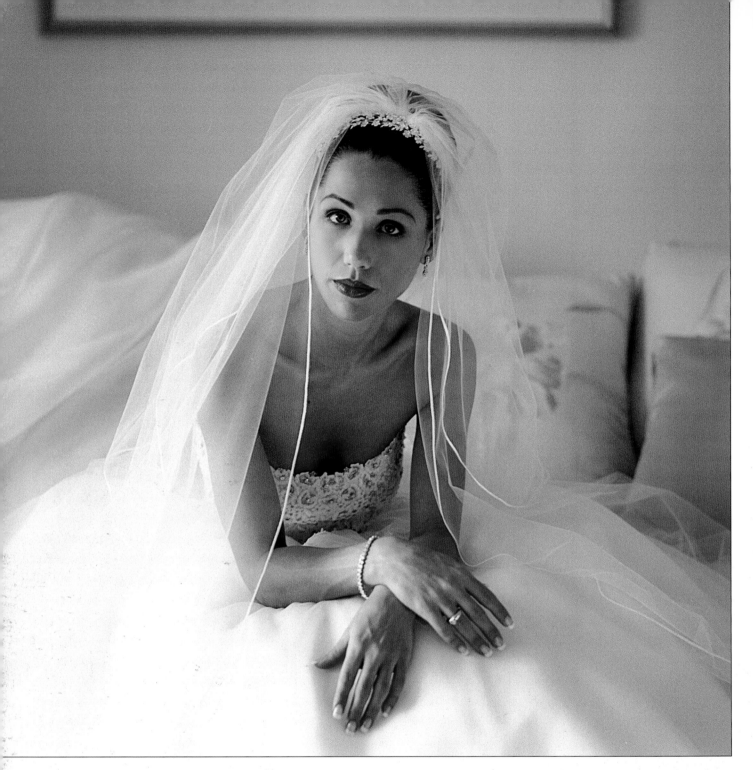

Before digital capture, if you had to correct this coloration, you would use a color-compensating filter over the lens. By selecting a complementary color filter, you could neutralize the color balance of the light. With digital you only need to perform a custom white balance or use one of the camera's pre-set white-balance settings, like "open shade." Those who use the ExpoDisc also swear by its accuracy in these kinds of situations.

There are times, of course, when you want the light on the skin to be warm, not just color-corrected. To do this, you can use a gold-foil reflector to bounce warm light onto the subject. The reflector does not change the color of the foliage or background, just the skin tones.

Good background control is part of good portrait technique on location. Anthony Cava made this portrait in a hotel room. Because it is difficult to control the subject-to-background distance in a room, he shot nearly wide open and moved his bride as far forward on the bed as possible so that he could blur the background effectively. The objects in the background are identifiable but not well defined, which is the quality to shoot for with backgrounds.

Existing light is often dull, overhead, and lifeless—making it totally unsuitable for fine photography. When working in these situations, you will need to augment and overpower that lighting. Fortunately, there are many types of high-intensity lights designed for location photography.

Light Sources

Portable Flash. Except as a fill-in source, undiffused on-camera flash should be avoided for making portraits. Its light is too harsh and flat and it produces

Sometimes straight flash is the only effective way to make an exposure. Photographer Cliff Mautner used a very slow shutter speed and panned the camera in the dim light to blur the background lights. The on-camera flash fired at the instant of hilarity, creating a priceless image.

Greg Gibson's base exposure for this scene was 1/20 second at f/2.8. He fired an on-camera flash to freeze his subjects and ensure he would not lose the priceless moment. Notice that the combination of straight flash and available light is not nearly as harsh as straight flash alone.

no roundness or contouring of the faces. When you diffuse on-camera flash, however, you get a softer frontal lighting, similar to fashion lighting (see page 44). There are various devices on the market for diffusing on-camera flash. Most can even be used with your flash in auto or TTL mode, making exposure calculation effortless. While the light is still flat and frontal in nature, it produces much better contouring—a big improvement over undiffused flash.

Bounce Flash. Portable electronic flash is difficult to use in combination with existing light. Because portable flash units do not have modeling lights, it is impossible to preview the lighting effect you will achieve. Still, when it is bounced off the ceiling or a side wall, portable flash produces efficient wrap-around lighting that can beautifully illuminate a portrait subject. The key is to aim the flash unit at a point on the wall or ceiling that will reflect the widest possible beam of light back onto your subject. Keep in mind that you should never bounce flash off colored walls or ceilings. The light reflected back onto

While the light is still flat and frontal in nature, it produces much better contouring.

your subjects will be the same color as the walls or ceiling and it will be almost impossible to correct, whether you're shooting film or digital.

A problem with bounce flash, especially with high ceilings, is that the light it produces comes from almost directly overhead. Fortunately, there are a number of devices on the market, like the Lumiquest ProMax system, that allow most of the flash's illumination to bounce off the ceiling while some is redirected forward as fill light. This solves the overhead problem of bounce flash. The Lumiquest system also includes interchangeable white, gold, and silver inserts, as well as a removable frosted diffusion screen. Additionally, Lumiquest offers devices like the Pocket Bouncer, which enlarges and redirects

With high ceilings, the light it produces comes from almost directly overhead.

Marcus Bell made this memorable image of the bride descending a circular staircase by pushing the limits of the available light. A very slow shutter speed of $^1/_{15}$ second was required to record the three levels of the photograph. A bounce flash at the top of the stairwell, where Bell was located with a very wide-angle lens, put just enough light on the bride to make her the focal point of the composition.

A dark hallway and a priceless moment—there was no time for anything but bounce flash off the ceiling, which not only preserved the moment, but was the perfect lighting choice for this image, giving it a journalistic real-time look. Photograph by Marcus Bell.

A good bounce-flash accessory is the Omni-Bounce, which is a frosted cap that fits over the flash head. The beam of light is diffused and can be used either as a diffused straight flash or in bounce mode for an even softer bounce effect. The Omni Bounce is manufactured to fit the popular Canon and Nikon speedlights.

light at a 90-degree angle from the flash to soften the quality of light and distribute it over a wider area. While no exposure compensation is necessary with TTL flash exposure systems, operating distances are somewhat reduced. With both systems, light loss is approximately $1\frac{1}{3}$ stops; with the ProMax system, however, using the gold or silver inserts will lower the light loss to approximately $\frac{2}{3}$ stop.

Diffusion. Quantum makes a device called the Mini Folding Softbox that allows you to shoot close-up portraits with portable flash, but yields an in-studio type of light, much like a large softbox. The mini softbox contains an extra layer of diffusion material, which reduces any hot spots and gives close to a full 180 degrees of light spread so it can be used with very wide-angle lenses. This makes it an excellent, highly portable source for photographers working on location.

Studio Strobes. Studio strobes come in two types: monolights and power-pack kits. Monolights are self-contained; simply plug one into a household AC socket and you're ready to go. Monolights also contain light triggers to fire the strobe when they sense the light of another strobe, so they can be used very far apart and are ideal for location lighting or large rooms.

Power-pack systems accept multiple strobe heads—up to four individual strobe heads can usually be plugged into a single moderately priced power pack. This type of system is most often used in studios, since you cannot move the lights more than about 25 feet from the power pack. Power-pack outlets are usually divided into two channels with variable settings, providing symmetrical or asymmetrical output distributed between one, two, three, or four flash heads.

This new Mini Folding Softbox from Quantum joins the Qflash family of specialized reflectors and produces studio-quality lighting from a portable flash.

Remote Triggering Devices. If using multiple flash units to light an area, some type of remote triggering device will be needed to sync all the flash units at the instant of exposure. There are a variety of these devices available; by far the most reliable, however, is the radio-remote triggering device. When you press the shutter release, these devices transmit a radio signal that is received by individual receivers mounted to (or in) each flash. This signal can be transmitted in either digital or analog form. Digital systems, like the Pocket Wizard Plus, are state of the art. Complex 16-bit digitally coded radio signals deliver a unique code, ensuring the receiver cannot be triggered or "locked

THE MAKING OF A REMARKABLE WEDDING PHOTOGRAPH

Marc Weisberg is a perfectionist, but when you see images like this, you know why. "It was late in the day and we were losing sun," he recalls. "The shadows that appear are actually from my trusty Quantum flash, mounted with a Bogen quick release plate on a Bogen tripod at camera left. Instead of using a light meter, which I use now for my large-group portraits to nail the exposure, I used my more expensive light meter, my Canon 1-D, set to manual, and dialed in the exposure while looking (at the meter scale) through the viewfinder. I shot a Canon 'Polaroid' to make sure that my histogram was not clipping the shadows or highlights. Then I set my Quantum flash one stop under and metered the flash output with my Sekonic L508 light meter. Pocket Wizards were used to trigger my Quantum flash. (I now use a Sekonic L358 with the built-in Pocket Wizard chip to fire my flashes and read ambient and flash output.)"

Marc created this image using a 17–35mm f/2.8 L lens on his Canon 1-D at ISO 200. The exposure was at $1/32$ second at f/5.7. Postproduction enhancements were used to complete the image. "The saturation was selectively bumped up with the saturation tool in Photoshop," says Marc, "and the LucisArt filter was used with a mask—this filter wrecks havoc on the skin, so I added the mask so that I could selectively apply the effects to the dress (bringing out the delicate folds) and to the shoes and tuxedos (to bring out the highlights better). I also used the LucisArt filter with a mask to bring out texture details in the walls, terracotta tiles and plants."

up" by other radio noise. The built-in microprocessor guarantees consistent sync speeds even under the worst conditions. Some photographers use a separate transmitter for each camera, as well as a separate one for the handheld flashmeter, allowing the photographer or an assistant to take remote flash readings from anywhere in the room.

Some of the latest DSLRs and their TTL flash systems allow you to set up remote flash units in groups, all keyed to the flash on the camera. Nikon's system of dedicated TTL flash units use an in-camera Flash Commander mode, where you can use the on-camera flash to trigger an array or several arrays of dedicated flash units. This is ideal for wedding receptions—provided you have a team of assistants to hold the mobile, cordless flash units. You could, for instance, photograph a wedding group with four synced flashes remotely fired from the camera location, all producing the desired output for the predetermined flash-to-daylight ratio. It's an amazing system, which many commercial photographers are now using for on-site multiple-light assignments.

Studio Light Modifiers. When the reflector is removed from the flash head, you have a barebulb light source. The light scatters in every direction—360 degrees. Removing the reflector has advantages if you have to place a light in a confined area. Some photographers use a barebulb flash as a background light for a portrait setting, positioning the light on a small floor stand directly behind the subject.

Acclaimed portrait photographer Don Blair was a big fan of barebulb flash, a tool he found to be versatile and multi-faceted. He said, "We can create

Some photographers use a barebulb flash as a background light.

The effect of a barebulb flash in this elegant bridal portrait is more than noticeable. Don Blair used a barebulb flash as a fill light beneath and to the right of the camera. The purpose of using the light as an auxiliary fill light was to add sparkle and "oomph" to the shadow side of the face, which it does to perfection.

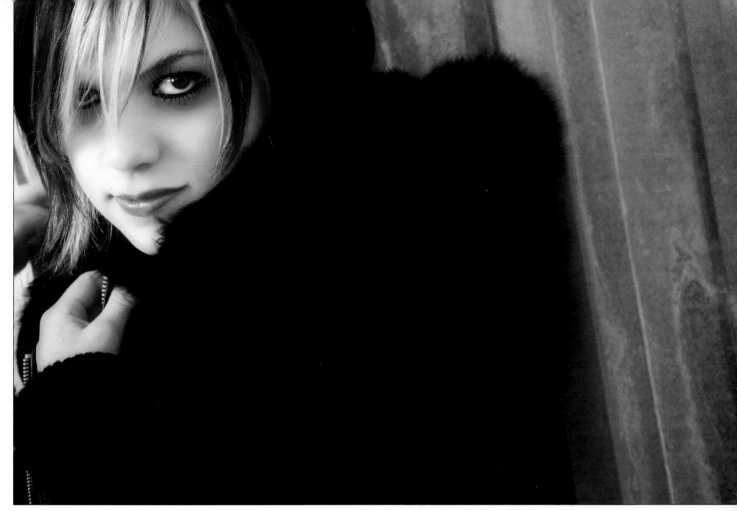

Here, Bruce Dorn used a small strobe with a Canon speedlight attached to a Strobe Slipper, a device he invented, inside a 24x24-inch softbox. The Strobe Slipper (see page 96) has a built-in shoe for a Pocket Wizard receiver, making the softbox wireless and remote. Dorn used the existing light as fill and overpowered the fill by about a stop to provide a soft key light to camera left. The Strobe Slipper, and similar devices, make it much easier to use softbox and umbrella lighting on location.

The Profoto FresnelSpot offers lighting adjustments between 10 and 50 degrees.

simple, effective lighting using the barebulb, but it seems to be a technique that photographers tend to overlook. I have made the barebulb one of the most important tools in my lighting arsenal. It can be used on location as a main light, an accent light, a fill light or simply as an overall supplementary light to brighten the entire scene. Used correctly, the barebulb gives a very natural look to the photograph and it adds specularity and punch—an extra burst of light that could be described as an explosion of light—that can turn a nice picture into a beautiful portrait."

A popular light modifier for studio strobes is the spotlight, a hard-light source that produces a well-defined shadow edge, giving more shape to the subject's features than diffused light sources. The spotlight is usually a small light with a Fresnel lens that focuses the light, making the beam of light stay condensed over a longer distance. Barn doors are commonly affixed to spots to further direct the beam of light. Spotlights are usually set to an output less than the main light or fill—unless they are being used as a key light, which is not uncommon in existing-light situations.

Another common light modifier is the grid spot, a honeycomb-like device that snaps onto the perimeter of the light housing. Grid spots usually come in 10-, 30-, and 45-degree versions. Each comb in the honeycomb grid prevents the light from spreading out (with the 10-degree grid providing the narrowest beam of light). Grid spots produce a narrow core of light with a diffused edge that falls off quickly to black. Because the light is collimated, there is very little spill with a grid spot—meaning they allow you to place light in a

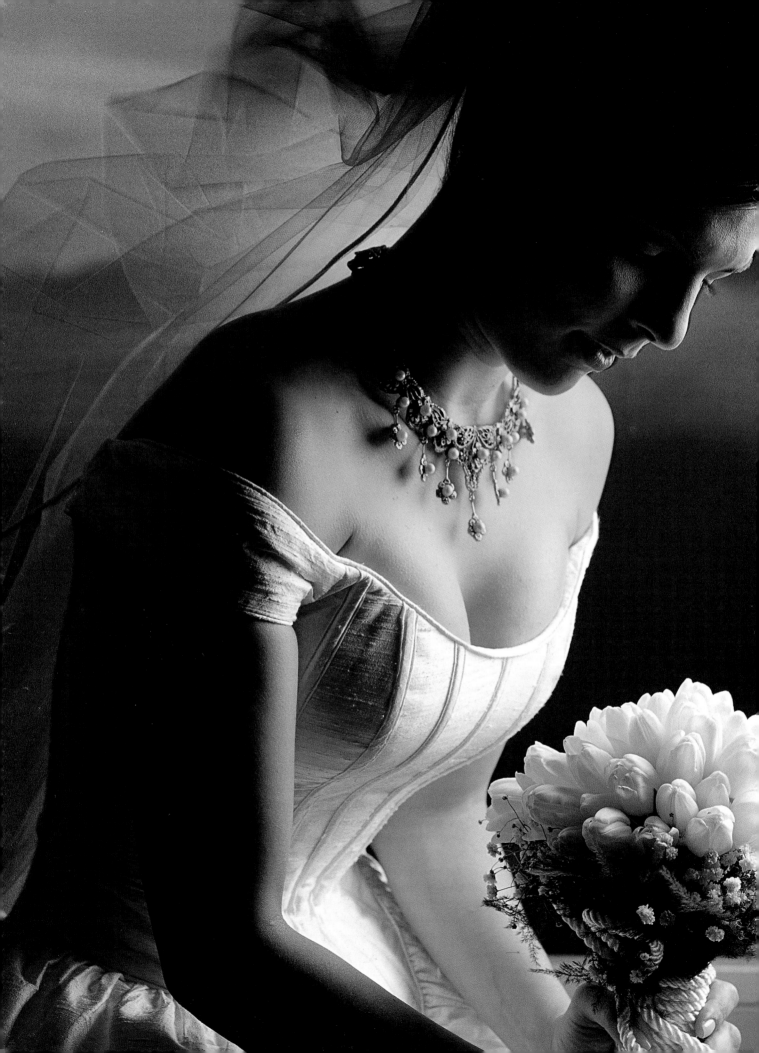

■ FOCUSING UMBRELLAS

To use an umbrella most effectively, the light should be focused correctly. Sliding the lamp head up and down the shaft with the modeling light on will show you the amount of light that escapes and is directed past the umbrella. When the beam of light is as wide as the perimeter of the opened umbrella, it is focused effectively.

FACING PAGE—Mauricio Donelli created this edgy bridal formal by using a softbox as a backlight. He often takes studio strobes on location to create elegant lighting with natural surroundings. The exposure was balanced with the ebbing daylight exposure to create a dramatic portrait at dusk. No fill was used to keep the lighting dramatic.

BELOW—Marcus Bell often takes an umbrella and strobe on location to his weddings for situations like this. The umbrella light is soft and directional. Fill light is coming from the tungsten light within the church and provides a golden fill to the shadow side of the face, while the strobe and umbrella are daylight-balanced. Notice the just visible sculpture in the background to the bride's left.

specific and relatively small area. This makes them ideal for portraits where a dramatic one-light effect is desired.

Photographic umbrellas, used to provide a more diffuse source of light, may be lined with matte white (for a very soft effect) or silver (for a slightly sharper effect). When using lights of equal intensity, a silver-lined umbrella can be used as a main light because of its increased intensity and directness. It will also produce specular highlights in the overall highlight areas of the face. A matte-white umbrella can then be used as a fill, or secondary light.

Some photographers use the umbrella in the reverse position, so that the light shines through the umbrella and onto the subject. This gives a softer, more directional effect than when the light is turned away from the subject and bounced into the umbrella. There are many varieties of shoot-through umbrellas available commercially and they act very much like softboxes.

Like umbrellas, softboxes produce light that is highly diffused. A softbox is basically black fabric box or enclosure with a front panel made of a light-diffusing material. This is fitted over one or more strobe heads to produce a soft, directional source of light. Softboxes come in a wide variety of sizes and shapes and may even be double-diffused with the addition of a second scrim over the lighting surface

When paired with existing light, both umbrellas and softboxes can be interchanged as key or fill light sources—and even added as hairlights and backlights when used in strip-light configurations (narrow rectangular softboxes). In using umbrellas and softboxes, it should be noted that the closer the light is to the subject, the softer the quality of the light will be. As the light is

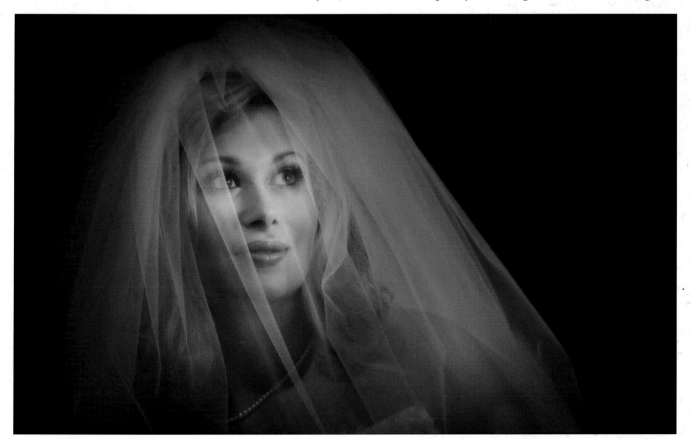

moved farther back, the sharper and less diffused the light becomes. While these light sources are extremely soft, it is still usually necessary to fill in the shadow sides of faces to prevent them from losing detail. The broad beam of light these sources produce is sometimes sufficient to light the background as well as the subject, although this depends on how far the background is from the light source).

Hot Lights. The beauty of using hot lights, which are continuous-light sources, is that (unlike with flash) you can always see what you're going to get photographically. This can make it much more straightforward and efficient to adjust your lighting to flatter the subject and harmonize with the existing light in a scene.

This can make it much more straightforward and efficient to adjust your lighting.

Using hot lights, however, does require some care and safety. A 1K light draws 1000 watts of power from any circuit into which it is plugged. A standard household circuit (20 Amp) provides 2000 watts of power at maximum capacity, which means with two 1K lights you will be using the maximum amount of power available on that circuit. If there is any other electrical device running on that circuit (anywhere in the building), you will trip the circuit breaker and lose power. As a result, photographers who use hot lights frequently carry lots of long extension cords, allowing them to power the lights from different outlets and distribute the load evenly over the electrical system.

Hot lights are also hot. The bulbs, lenses, casings, and sometimes even the stands themselves get quite warm. For that reason, using heavy leather gloves is recommended when working with the lights. This is especially important when changing bulbs; the gloves will protect you from burns, but will also protect the new bulb from oils on your fingers that can be deposited

THE STROBE SLIPPER

Bruce Dorn has come up with a remote softbox that he uses on location called the Strobe Slipper (available from his website: www.idcphotography.com). As you can see from the setup shot, the Photoflex softbox is small and maneuverable and uses a Canon (or Nikon) speedlight mounted to a stainless steel plate, which also holds a Pocket Wizard receiver. The transmitter is mounted in the hot shoe of Dorn's Canon EOS DSLR.

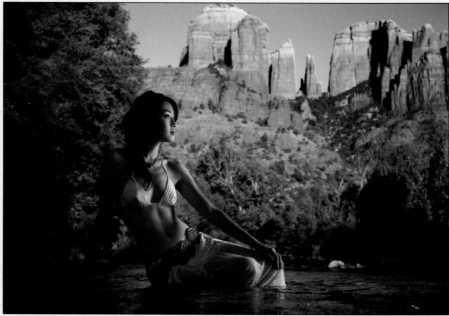

The Strobe Slipper is shown to the left with a Pocket Wizard receiver mounted on a PhotoFlex heavy-duty Swivel with a PhotoFlex Adjustable Shoe Mount and a Q39 X-small softbox. In the image above, the Strobe Slipper was used facing the model and allowed to wrap around her with no reflector. The strobe exposure was balanced with the daylight exposure for a perfect combination of daylight and studio strobe.

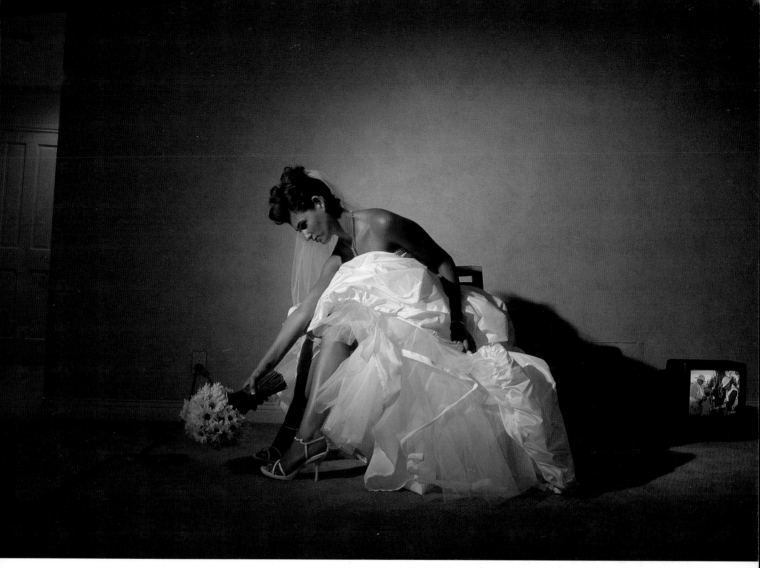

Cherie Steinberg Coté used a 1K Mole Richardson light to create this unusual portrait of a bride. As her assistant held the light, Cherie used an 18mm lens to widen the view so that she could include the room as part of the composition. The light cord from the 1K light is intentional and quirky enough to be a pleasant bonus in the composition. Note how well the light feathers (falls off at the edges), as seen on the back wall.

The Westcott Spiderlite TD5 can be configured with five coiled fluorescent tubes, four AC-powered strobes with a fluorescent modeling light, or five tungsten bulbs—all in a compact housing that fits nicely into a 24x32-inch softbox.

on the bulb surface and cause the glass to explode (this is particularly true for quartz-halogen bulbs).

Another good practice is to unplug lights before you attempt to change a bulb. Equally, you should make sure the lights are turned off at the switch before plugging them in. It's also recommended that you use sandbags to secure light stands that are extended into the air or have boom arms attached.

Daylight-Balanced Fluorescents. Daylight-balanced photographic fluorescent light sources, have become very popular among photographers in recent years. As continuous sources, they offer the same ease of use as hot lights, but without some of the problems. First, they are daylight-balanced (or just slightly warmer), meaning that they can be used seamlessly outdoors or with windowlight; there are no problematic color-balance issues to worry about. Additionally, they are cool running, so fluorescents can be used in studio light modifiers, like softboxes, without concern.

Photographer Bruce Dorn found a recent bridal-portrait scenario was a perfect opportunity to work with one of his favorite lighting instruments, the Westcott Spiderlite TD5 in a matching Westcott 32x48-inch softbox. Although the Spiderlite may be fitted with strobes or tungsten globes, Dorn chose the third option, installing a full set of Westcott's daylight-balanced fluorescent lamps. These are approximately 5500K, giving them a somewhat

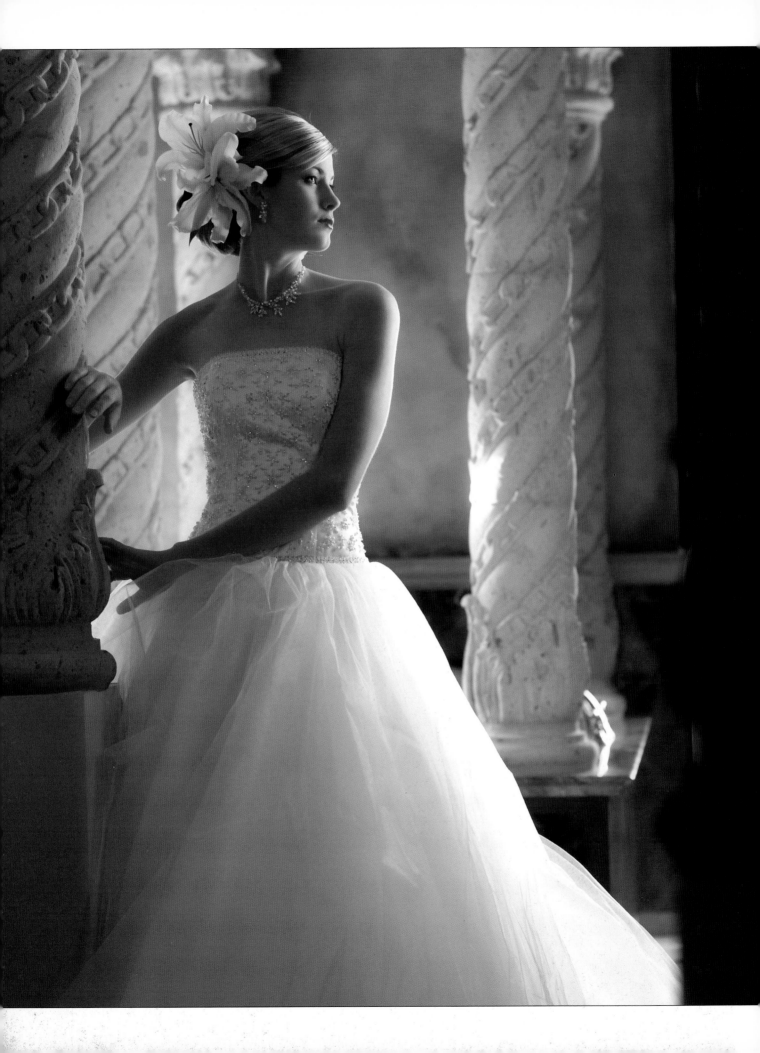

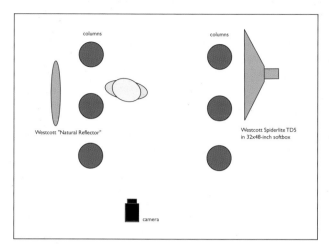

columns columns

Westcott "Natural Reflector"

Westcott Spiderlite TD5
in 32x48-inch softbox

camera

ABOVE AND FACING PAGE—Daylight-balanced fluorescents, here warmed to balance with the room's tungsten lighting, are a popular choice for location lighting. Photograph by Bruce Dorn.

In a darkened pub, wedding photographer Yervant used a handheld video light (held by an assistant) to light this dazzling portrait. The key was balancing the room lights with the video light, which can be accomplished by either decreasing the power of the video light or feathering the light's main core away from the subject.

warmer feeling than the skylight that was spilling in through the well-shaded windows.

This is an important point for beginners and advanced practitioners alike: it is up to the photographer to understand and control the relationships between the color temperatures of the principle light sources and the white-balance setting chosen for the camera. In this case, Bruce wanted the skylight to stay slightly cool or bluish, so he set the camera's color temperature to 5000K. He then elected to further warm up the 5500K light from the Spiderlite to emulate the cozy feel of the tungsten-lit interior. To accomplish this, he covered the softbox's front diffuser with a large sheet of Lee Filters' .5 CTO gelatin filter. This gel warms any light source by about 1000K and makes the light from these 5500K fluorescent lights behave as if they were an invitingly warm 4500K.

After carefully placing the softbox slightly beyond the model, Bruce's assistant tucked himself behind a column, where he handheld a prototype of the Westcott "Natural Reflector," a pop-open muslin, for just a gentle touch of fill. To learn more about this shoot, check out *Bruce Dorn Presents Vintage Glamour: Exploring Light, Discovering Style,* available from www.idcphotography.com/store.

Handheld Video Lights. Photographer David Williams uses small 20- and 50-watt handheld video lights to augment existing light at a wedding or on location. He has glued a Cokin filter frame to the front of each light and places a medium blue filter (a 025 Cokin) in the holder. The filter brings the white balance back from tungsten to about 4500K, which is still warmer than

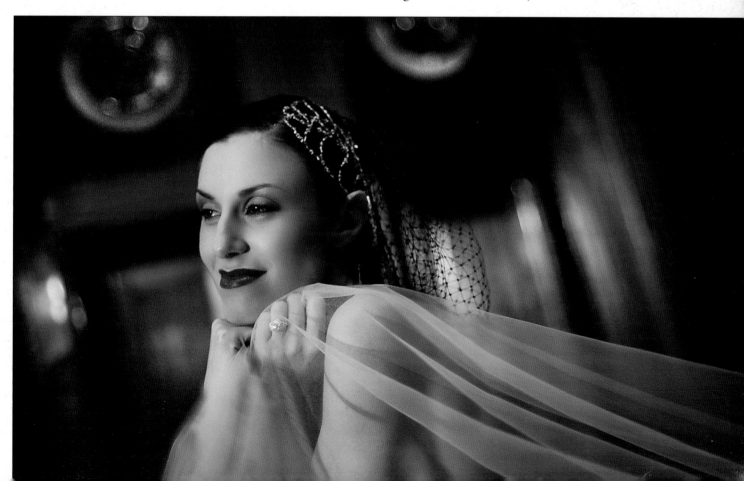

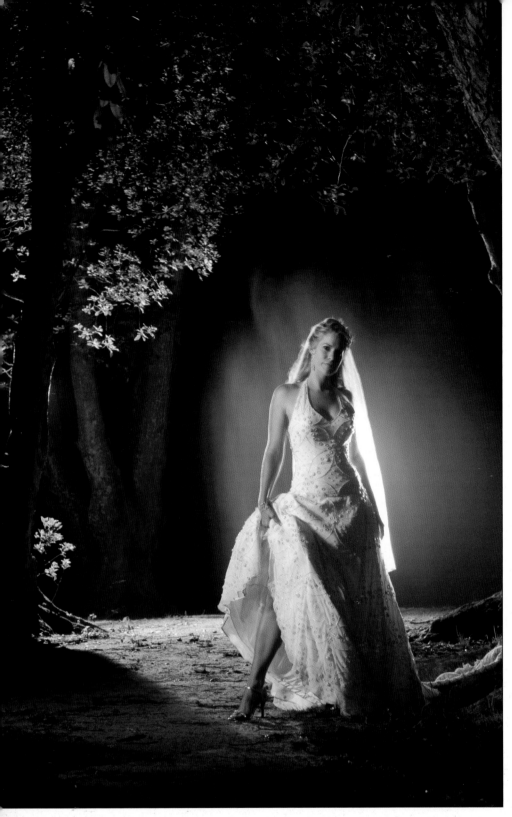

In this sylvan bridal portrait, Brett Florens had one assistant hold a two-million candlepower flashlight as a backlight and another assistant hold a flash unit to illuminate the bride from the side.

daylight. It is the perfect warm fill to pair with existing light. If you want an even warmer effect, or if you are shooting indoors with tungsten lights, you can simply remove the filter.

Used close to the subject (within six to eight feet) these lights are fairly bright, but they can be bounced or feathered to cut the intensity. Some also have variable power settings, from 10 to 100 watts, that allow you to control the effect you achieve. David tends to use them when shooting wide open, so they are usually just added to create fill or accent lighting.

The video light can also be used to provide what David calls, a "kiss of light." For this effect, he holds the light above and to the side of the subject and feathers it back and forth while looking through the viewfinder. The idea is to produce just a little warmth and light on a backlit object or something that is lit nondescriptly and needs a little pizzazz.

Sometimes David even uses an assistant to hold two lights, each canceling out the shadows from the other. He has even combined these in a flash-bracket arrangement with a handle that he himself can control. This dual video light has a palm grip attached to the bottom to make it more maneuverable when he has the camera in his other hand.

Flashlights. Proving that there is no reason to be limited in the types of lighting you use in your images, photographer Brett Florens has found that one light source he can rely on for really spectacular backlighting effects is a

Cherie Steinberg Coté created this wonderful high-fashion image with a Dyna-Lite Jackrabbit kit, which includes two strobe heads and portable rechargeable batteries. Cherie says, "We were lucky to get these shots. It was sunset and the sky was perfect. With the two Dyna-Lite strobes, we popped the model and the second flash was feathering the helicopter."

FACING PAGE—TTL-balanced fill flash is extremely accurate with today's DSLRs and dedicated flash systems. Cherie Steinberg Coté made this wonderful fashion portrait of a bride in a direct-sun situation, placing the bride in an area of shade. Her main lighting was Nikon's Matrix-balanced flash with a Nikon D70 and SB-80 DX flash. These systems are so precise that you can set flash or exposure compensation in $\frac{1}{3}$-stop increments. The system will defy your imagination with its uncanny accuracy, allowing you to concentrate on the composition and posing and not the nuts and bolts of balancing flash and daylight. In this instance, Cherie dialed in +$\frac{2}{3}$ stop of flash compensation so that the flash would become the key light, overpowering the shade exposure and producing pure white tones in the dress and accurate skin tones.

Cherie Steinberg Coté made this wonderful fashion portrait of a bride in a black veil on a downtown Los Angeles bridge. Her main lighting was matrix-balanced flash with a Nikon D70 and SB-80 DX flash.

two-million candlepower flashlight. This is often operated by an assistant while Brett photographs the wedding couple during their first dance, but Brett has been known to use it in other applications as well (as seen in the bridal portrait on page 100).

Adding Fill Light

Barebulb Fill. One of the most frequently used handheld flash units is the barebulb flash, which acts more like a large point source light than a small portable flash. Barebulb units produce a sharp, sparkly light, that is too harsh for almost every type of photography except outdoor portraits. Because the light falloff is less than with other handheld units, however, barebulb is an ideal source of fill light—either for backlit subjects or when a little punch of light is needed on sunlit subjects photographed early in the morning or at sunset when the sun is low in the sky. Barebulb units are predominantly manual flash units, so you must adjust their intensity by changing the flash-to-subject distance or by adjusting the flash output level. But whatever control you choose, the trick is not to overpower the daylight.

Softbox Fill. Some photographers like to soften their fill-flash. Robert Love, for example, uses a Lumedyne strobe in a 24-inch softbox, which he triggers with a radio remote control. He often uses this at a 45-degree angle

to his subjects (particularly for small groups) to create a modeled fill-in. For larger groups, he uses the softbox next to the camera for more even coverage.

To measure and set the light output for a fill-in flash situation, begin by metering the scene. It is best to use a handheld incident meter with the hemisphere pointed at the camera from the subject position. In this hypothetical example, let's imagine that the metered exposure is $\frac{1}{15}$ second at f/8. Now, with a flashmeter, meter the flash only. Your goal is for the output to be one stop less than the ambient exposure, so adjust the flash output or flash-to-subject distance until your flash reading is f/5.6, and set the camera to $\frac{1}{15}$ sec-

Anthony Cava had this family pose under the tree, which blocked the overhead nature of the open shade. He then used flash-fill to add some sparkle to the faces.

ond at f/8. At this point, if shooting digitally, it's a good idea to take test shot.

On-Camera Flash Fill. Other photographers prefer to use on-camera TTL flash. Many of these systems feature a mode that will instantly adjust the flash output to the ambient-light exposure for balanced fill-flash. Many such systems also offer flash-output compensation that allows you to dial in full- or fractional-stop output changes for the desired ratio of ambient-to-fill illumination. They are marvelous systems and, more importantly, they are reliable and predictable. Some of these systems also allow you to remove the

They are marvelous systems and, more importantly, they are reliable and predictable.

Joe Buissink created this lovely and unique outdoor portrait of a barefoot bride sitting against a flowered wall. Joe used flash fill to get some twinkle in her eyes and added a canvas-effect to the image in postproduction.

LEFT—Modern TTL-metered flash is the best way to set the ratio between existing light and bounce flash. Here, Dennis Orchard captured window light, incandescent room light, and bounce flash in a single exposure. The bounce flash was fired simply to open up the shadow side of the girl's face and it is quite minimal.

FACING PAGE—Al Gordon used a studio strobe as a flash-key at sunset. He wanted to exploit the incredible sunset colors of the scene so he let the background exposure be almost two full stops less than the strobe exposure to produce highly saturated color in the sky and ocean. The photographer positioned the strobe to camera left and above the couple in order to produce a dramatic light quality.

flash from the camera with a TTL remote cord, increasing the range of effects you can produce.

Flash Key Techniques

While location portraiture often calls for the existing light to function as the key light, there are some cases where the existing light is not ideal for this purpose. In these circumstances, you may wish to overpower the existing light and use flash as your key-light source.

There are some cases where the existing light is not ideal for this purpose.

When adding flash as the key light, it is important to remember that you are balancing two light sources in one scene. The ambient-light exposure will dictate the exposure on the background *and* the subjects. The flash exposure affects *only* the subjects. Essentially, you are "dragging the shutter"—meaning that you are setting the camera to a shutter speed slower than the X-sync speed (the fastest speed at which you can fire the camera with a strobe attached). The shutter remains open after the flash fires, allowing the ambient light to properly expose the background. Understanding this concept is the essence of flash-fill.

When using the flash-key technique, it is best if the flash can be removed from the camera and positioned above and to one side of the subject. This will

It is important to remember that you are balancing two light sources in one scene.

Don't think too hard about the direction of the main light in this stylized bridal portrait; it has been altered by the introduction of a Strobe Slipper (see page 96) used to camera left as a soft key light. The strong shadows produced by direct sunlight still exist, but would have been a disaster had that light been the primary light source for this image. The exposure was $^1/_{250}$ second at f/16, one stop greater than the daylight exposure for bright sunlight. Photograph by Bruce Dorn.

With the window light blocked by the opaque screens in the background, the only way to bring light to the scene was via bounce flash, which Kersti Malvre used expertly.

The problem with this is that you will get a separate set of shadows from the flash.

more closely imitate nature's light, which always comes from above and never head-on. Moving the flash to the side will improve the modeling qualities of the light and show more roundness in the face. It is also unwise to override the ambient light exposure by more than two f-stops. This will cause a spotlight effect and render the background so dark that the portrait may appear to have been shot at night.

Saturating Backgrounds. If the light is dropping or the sky is brilliant in the scene and you want to shoot for optimal color saturation in the background, you can overpower the daylight with flash. Returning to the hypothetical situation where the daylight exposure is $\frac{1}{15}$ second at f/8 (see page 104), you would now adjust your flash output so your flashmeter reading is f/11, a stop more powerful than the daylight. Then, you would set your camera to $\frac{1}{15}$ second at f/11. The flash is now the key light and the daylight is the fill light. The problem with this is that you will get a separate set of shadows from the flash. This can be acceptable, since there aren't really any shadows from twilight, but keep it in mind that it is one of the side effects.

When using this technique to photograph more than one person, remember that electronic flash falls off in intensity rather quickly. As a result, you must be sure to take your meter readings from the center and—to be

LEFT—Knowing the effect of backgrounds on exposure meters is crucial for a scene like this. Anthony Cava, a photographer well known for his fine portraits, shot this image as a commercial portrait for a clothing-design catalog. He metered the available light, decided to underexpose his background by almost a full f-stop, and fired an umbrella-mounted studio flash to provide brilliance and facial modeling. The light was positioned above and to the right of the model, creating a "loop" like pattern. No fill was used. The image was made with a Nikon D1X, 80–200mm zoom (at 80mm setting) at an exposure of $1/30$ second at f/3.5

FACING PAGE—As you look at this photograph by Dan Doke, you might think the hotel's outdoor lighting was very, very bright to create such sharp-edged shadows. Not so. The tungsten lighting is window dressing. The lighting pattern came from a hot (undiffused) strobe positioned behind the couple on a light stand. A diffused fill strobe at the camera position was used to create frontal detail in the image. The working wedding photographer must know how to use existing light as well as when to add his or her own lighting in conjunction with the available light.

safe—from either end of the subject area. With a small group of three or four people you can get away with moving the strobe away from the camera to get better modeling—but not with larger groups; the falloff is too great. You can, however, add a second flash of equal intensity and distance on the opposite side of the camera to help widen the light. If using two light sources, be sure to measure both flashes simultaneously for an accurate reading.

Overcast Days. When the flash exposure and the daylight exposure are identical, the effect is like creating your own sunlight. This works particularly well when used on overcast days with barebulb flash, which mimics the light quality of the sun. Position the flash to the right or left of the subject and el-

If using two light sources, be sure to measure both flashes simultaneously.

evate it for better facial modeling. If you want to accentuate the lighting pattern and darken the background, set the flash output at ½ to one stop greater than the daylight exposure and expose for the flash exposure. Do not underexpose your background by more than two stops, however, or you will produce an unnatural nighttime effect.

Many times this effect will allow you to shoot in overhead daylight without fear of creating shadows that hollow the eye sockets. The overhead nature of the daylight will be overridden by the directional flash, which creates its own lighting pattern.

One suggestion is to warm up the flash by placing a warming gel over the barebulb flash's clear shield. The gel will warm the facial lighting, but not the rest of the scene. It's a beautiful effect.

Warm up the flash by placing a warming gel over the barebulb flash's clear shield.

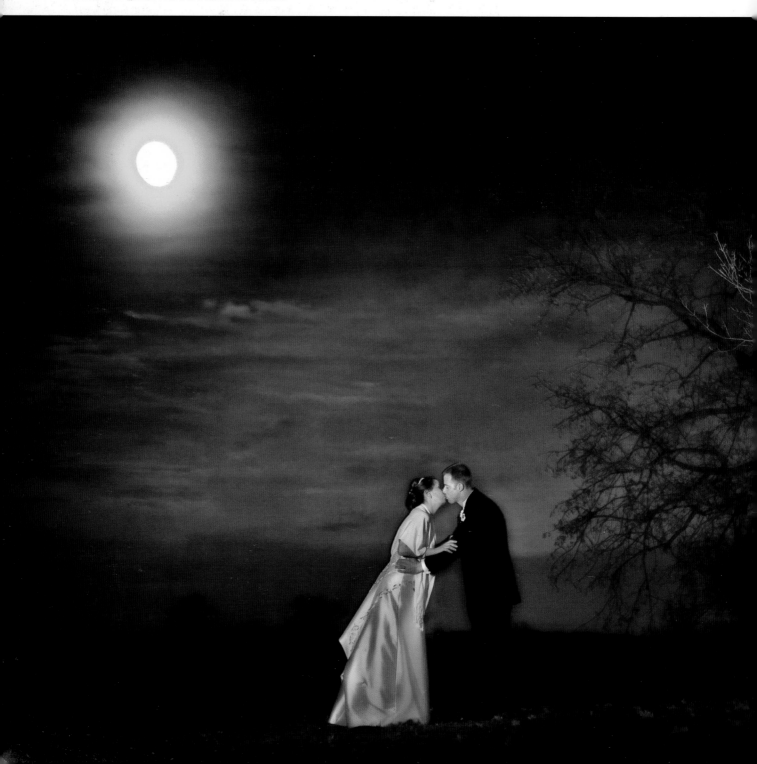

RIGHT—Marc Weisberg, working in subdued light aboard a moving yacht, fired an off-camera flash to overpower the available light. His flash exposure was about one stop hotter than the daylight exposure, darkening the background as if it were dusk. The off-camera flash was held high and to camera left to effectively model the couple, creating a flattering lighting in an otherwise tricky lighting situation.

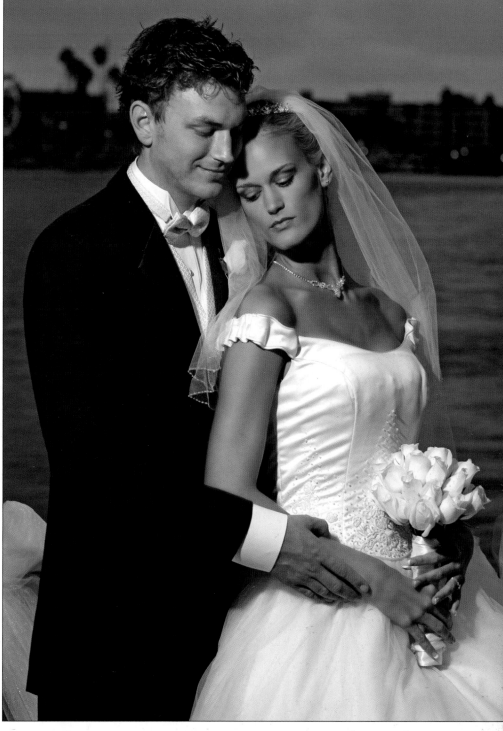

LEFT—This image by Greg Gibson is a lighting tour de force. With a full moon and spot lighting nearby, Greg made the exposure at 1.3 seconds at f/2.8 with his tripod-mounted Canon EOS 5D. To freeze potential camera or subject motion, he fired a flash from the camera position, matching its intensity to the nighttime exposure. If you look closely, you can see a faint black line around the subjects where they moved slightly during the exposure, effectively revealing the darkness behind them. The white balance was set to a custom setting of 6100K to correctly color balance the flash exposure; everything else was warmed by the tungsten lighting. The saturation and brightness were increased in RAW file processing, while the moon and sky were darkened in Photoshop.

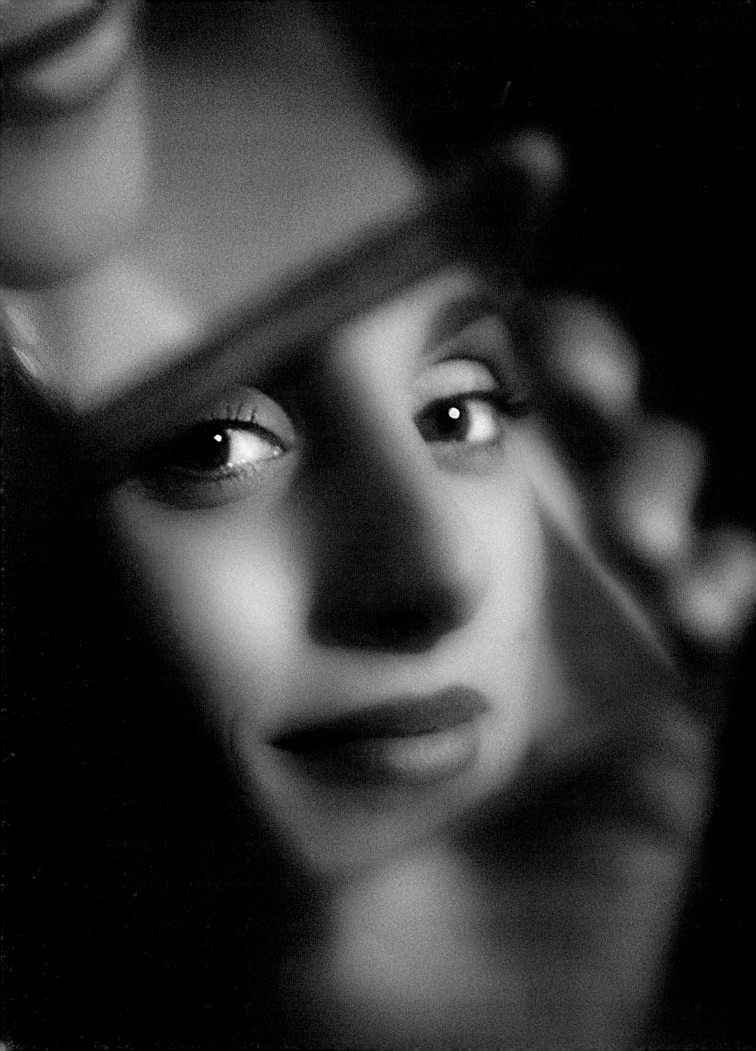

FACING PAGE—Yervant uses Lowel 55- and 100-watt handheld video lights called the I-light. In this great image, made by photographing the bride's reflection in her makeup mirror, the light was feathered delicately by an assistant so that the lighting was crisp and dynamic.

One light can effectively model the features of a single subject or small group.

Direct Sunlight. If you are forced to shoot in direct sunlight (the background or location may be irresistible) position your subject with the sun behind them and use flash to create a frontal lighting pattern. The flash, optimally set in a reflector or diffuser of some type to focus the light, should be set to produce the same exposure as the daylight. The daylight will act like a background light; the flash, set to the same exposure, will act like a key light. If your exposure is $\frac{1}{500}$ second at f/8, for example, your flash would be set to produce an f/8 on the subject. Position the flash to one side of the subject and elevate it to produce good facial modeling. An assistant or light stand will be called for in this lighting setup. You may also want to warm the flash output with a warming gel over the flash reflector.

Additional Lighting Tips

Master One Light. If you want to improve your location-portrait lighting techniques drastically in a relatively short time, learn to use one light to do the job of many. One light can effectively model the features of a single subject or small group with relative ease. Whether you own strobe, portable, or studio-flash equipment, tungsten or quartz-halogen lighting equipment, you will get your money's worth from it by learning to use one light well. You will also better understand lighting and learn to "see" good lighting by mastering the use of a single light.

Feather the Light. When you add an artificial light source to the existing light, feathering it is the only way to attain good lighting and highlight brilliance. This means that instead of aiming the light so that its core strikes the subject (the core is often unforgivingly harsh), you direct the light past the subject, employing more of the edge of the light. When doing this, it is best to have an assistant position the light, as you must judge the effect of the light from the camera position.

Conclusion

As of this writing, the technological bar has been significantly raised by the introduction of the new Canon EOS-1Ds Mark III and Nikon D3 DSLRS. Both cameras feature "live view" preview, a video preview of the live scene on the camera's three-inch LCD. Both also feature enhanced image-processing speeds, which means more frames per second and larger image buffers for more high-resolution RAW captures in less time. They also offer enhanced systems with up to 51 (Nikon) or 45 (Canon) discrete focus points in the autofocus matrix. Additionally, Canon offers an on-board automatic sensor-cleaning system, ridding frames of unwanted dust and other artifacts, while Nikon's offering introduces significantly increased noise reduction and wildly high ISOs (up to ISO 25,600), drastically enhancing the system's low-light capturing capability. Both systems boast blazingly fast AF systems and enhanced auto-TTL flash features, as well.

The bottom line is that technology is king—and the ability of these new systems to capture full dynamic-range images in any kind of light is becoming nothing short of phenomenal. To portrait and wedding photographers who make their living dealing with the unpredictable nature of existing-light photography, these technological developments only serve to extend their considerable talents over an ever-widening playing field.

But aesthetic success is not built on technology, necessarily. The best pictures are born of great insight and the ability to react spontaneously to changing light and scene conditions. While good tools help, the best photographers have built their considerable reputations on less quantifiable factors, like the ability to truly see and analyze light and exploit it to its fullest potential. That will always be true, regardless of high-tech advances.

The best pictures are born of great insight and the ability to react spontaneously.

Absorption. One of the characteristics of light. Absorption occurs when no light is transmitted or reflected from a surface. Absorption usually results in heat, but not light.

Angle of incidence. The original axis on which light travels. The angle of reflection is the secondary angle light takes when reflected off of some surface. The angle of incidence is equal to the angle of reflection.

Barebulb flash. A portable flash unit with a vertical flash tube that fires the flash illumination 360 degrees.

Barn doors. Black, metal folding doors that attach to a light's reflector. These are used to control the width of the beam of light.

Black flag. Light-blocking card that is supported on a stand or boom and positioned between the light source and subject to selectively block light from portions of the scene. Also known as a gobo.

Boom arm. A light stand accessory that uses a heavy counterweight on one end of a pole to balance the weight of a softbox or other light modifier.

Bounce flash. Bouncing the light of a studio or portable flash off a surface such as a ceiling or wall to produce indirect, shadowless lighting.

Broad lighting. One of two basic types of portrait lighting in which the key light illuminates the side of the subject's face turned toward the camera.

Burning-in. A darkroom technique in which specific areas of the print surface are given additional exposure in order to darken them. Emulated in Photoshop.

Butterfly lighting. One of the basic portrait lighting patterns, characterized by a high key light placed directly in line with the line of the subject's nose. This lighting produces a butterfly-like shadow under the nose. Also called paramount lighting.

Catchlight. The specular highlights that appear in the iris or pupil of the subject's eyes, reflected from the portrait lights.

CC filters. Color-compensating filters that come in gel or glass form and are used to correct the color balance of a scene.

Color temperature. The degrees Kelvin of a light source. Also refers to a film's sensitivity. Color films are balanced for 5500K (daylight), or 3200K (tungsten) or 3400K (photoflood).

Depth of field. The distance that is sharp beyond and in front of the focus point at a given f-stop.

Diffusion flat. Portable, translucent diffuser that can be positioned in a window frame or near the subject to diffuse the light striking the subject. Also known as a scrim.

Dodging. Darkroom printing technique or Photoshop technique in which specific areas of the print are given less print exposure by blocking the light to those areas of the print, making those areas lighter.

Dragging the shutter. Using a shutter speed slower than the X sync speed in order to capture the ambient light in a scene.

Fashion lighting. Type of lighting that is characterized by its shadowless light and its proximity to the lens axis. Fashion lighting is usually head-on and very soft in quality.

Feathering. Misdirecting the light deliberately so that the edge of the beam of light illuminates the subject.

`Fill card. A white or silver-foil-covered card used to reflect light back into the shadow areas of the subject.

Fill light. Secondary light source used to fill in the shadows created by the key light.

Flash-fill. Flash technique that uses electronic flash to fill in the shadows created by the main light source.

Flash-key. Flash technique in which the flash becomes the main light source and the ambient light in the scene fills the shadows created by the flash.

Flashmeter. A handheld incident light meter that measures both the ambient light of a scene and when connected to an electronic flash, will read flash only or a combination of flash and ambient light. They are invaluable for determining outdoors flash exposures and lighting ratios.

Flat. A large white or gray reflector usually on casters that can be moved around a set for bouncing light onto the set or subject.

45-degree lighting. Portrait lighting pattern characterized by a triangular highlight on the shadow side of the face. Also called Rembrandt lighting.

Fresnel lens. The glass filter on a spotlight that concentrates the light rays in a spotlight into a narrow beam of light.

Gobo. Light-blocking card that is supported on a stand or boom and positioned between the light source and subject to selectively block light from portions of the scene.

High-key lighting. Type of lighting characterized by low lighting ratio and a predominance of light tones.

Highlight brilliance. Refers to the specularity of highlights on the skin. A negative with good highlight brilliance shows specular highlights (paper base white) within a major highlight area. Achieved through good lighting and exposure techniques.

Histogram. A graph associated with a single image file that indicates the number of pixels that exist for each brightness level. The range of the histogram represents 0–255 from left to right, with 0 indicating "absolute" black and 255 indicating "absolute" white.

Hot spots. A highlight area of the negative that is overexposed and without detail. Sometimes these areas are etched down to a printable density.

Incident light meter. A handheld light meter that measures the amount of light falling on its light-sensitive dome.

Inverse Square Law. A behavior of light that defines the relationship between light and intensity at varying distances. The Inverse Square Law states that the illumination is inversely proportional to the square of the distance from the point source of light.

Key light. The main light in portraiture used to establish the lighting pattern and define the facial features of the subject.

Kicker. A backlight (a light coming from behind the subject) that highlights the hair or contour of the body.

Levels. In Photoshop, Levels allows you to correct the tonal range and color balance of an image. In the Levels window, Input refers to the original intensity values of the pixels in an image and Output refers to the revised color values based on your adjustments.

Lighting ratio. The difference in intensity between the highlight side of the face

and the shadow side of the face. A 3:1 ratio implies that the highlight side is three times brighter than the shadow side of the face.

Loop lighting. A portrait lighting pattern characterized by a loop-like shadow on the shadow side of the subject's face. Differs from paramount or butterfly lighting because the main light is slightly lower and farther to the side of the subject.

Low-key lighting. Type of lighting characterized by a high lighting ratio and strong scene contrast as well as a predominance of dark tones.

Main light. Synonymous with key light.

Modeling light. A secondary light mounted in the center of a studio flash head that gives a close approximation of the lighting that the flash tube will produce. Usually high intensity, low-heat output quartz bulbs.

Monolight. A studio-type flash unit that is self-contained, including its own capacitor and discharge circuitry. Monolights come with built-in flash triggers so the light can be fired without directly connecting the flash to a camera or power pack.

Parabolic reflector. Oval-shaped dish that houses a light and directs its beam outward in an even controlled manner.

Paramount lighting. One of the basic portrait lighting patterns, characterized by a high key light placed directly in line with the line of the subject's nose. This lighting produces a butterfly-like shadow under the nose. Also called butterfly lighting.

Point light source. A sharp-edged light source like the sun, which produces sharp-edged shadows without diffusion.

Reflected light meter. A meter that measures the amount of light reflected from a surface or scene. All in-camera meters are of the reflected type.

Reflection. One of the behaviors of light. Light striking an opaque or semi-opaque surface will either reflect light at various angles, transmit light through the surface or be absorbed by the surface.

Reflector. (1) Same as fill card. (2) A housing on a light that reflects the light outward in a controlled beam.

Refraction. One of the behaviors of light. When light is transmitted through a surface, it changes speed and is misdirected at an angle different from its incident angle. Different surfaces predictably bend or refract light in known quantities. The definition of a given material's refractive characteristics is known as its Refractive Index.

Rembrandt lighting. Same as 45-degree lighting.

Rim lighting. Portrait lighting pattern where the key light is behind the subject and illuminates the edge of the subject. Most often used with profile poses.

Scatter. A characteristic of light. When light is transmitted through a translucent medium in changes directions and is transmitted at a wide variety of different angles. The transmitted light is known as scatter.

Scrim. A panel used to diffuse sunlight. Scrims can be mounted in panels and set in windows, used on stands, or they can be suspended in front of a light source to diffuse the light.

Shadow. An area of the scene on which no direct light is falling making it darker than areas receiving direct light; i.e. highlights.

Shadow edge. Where a highlight and shadow meet on a surface is the shadow edge. With hard light, the shadow edge is abrupt. With soft light the shadow edge is gradual. Also known as the transfer edge.

Sharpening. In Photoshop, filters that increase apparent sharpness by increasing the contrast of adjacent pixels within an image.

Short lighting. One of two basic types of portrait lighting in which the key light illuminates the side of the face turned away from the camera.

Slave. A remote triggering device used to fire auxiliary flash units. These may be optical, or radio-controlled.

Softbox. Black fabric box with a front diffusion screen used to soften light. It can contain one or more light heads and single or double-diffused scrims.

Specular highlights. Sharp, dense image points on the negative. Specular highlights are very small and usually appear on pores in the skin. Specular highlights are pure white with no detail.

Split lighting. Type of portrait lighting that splits the face into two distinct areas: shadow side and highlight side. The key light is placed far to the side of the subject and slightly higher than the subject's head height.

Spotmeter. A handheld reflected light meter that measures a narrow angle of view—from 1° to 4°, usually.

Spots. Spotlights; a small sharp light that uses a Fresnel lens to focus the light from the housing into a narrow beam.

Straight flash. The light of an on-camera flash unit that is used without diffusion; i.e., straight.

Subtractive fill-in. Lighting technique that uses a black card to subtract light out of a subject area in order to create a better defined lighting ratio. Also refers to the placement of a black card over the subject in outdoor portraiture to make the light more frontal and less overhead in nature.

TTL-balanced fill-flash. Flash exposure systems that read the flash exposure through the camera lens and adjust flash output to compensate for flash and ambient light exposures, producing a balanced exposure.

Transfer edge. See shadow edge.

Umbrella lighting. Type of soft, casual lighting that uses one or more photographic umbrellas to diffuse the light source(s).

Unsharp mask. A sharpening tool in Adobe Photoshop that is usually the last step in preparing an image for printing.

Vignette. A semicircular, soft-edged border around the main subject. Vignettes can be either light or dark in tone and can be included at the time of shooting, or added later in printing.

Watt-seconds. Numerical system used to rate the power output of electronic flash units. Primarily used to rate studio strobe systems.

White balance. The camera's ability to correct color and tint when shooting under different lighting conditions including daylight, indoor, and fluorescent.

Wraparound lighting. Soft type of light, produced by umbrellas, that wraps around the subject, producing a low lighting ratio and open, well-illuminated highlight areas.

X sync. The shutter speed at which focal-plane shutters synchronize with electronic flash.

Zebra. A term used to describe reflectors or umbrellas having alternating reflecting materials such as silver and white cloth.

Jennifer Baciocco. Jennifer Baciocco is a graduate of Brooks Institute of Photography and shoots weddings and portraits in Northern California. Visit her website at www.jenniferbaciocco.com.

Fernando Basurto *(APM, AOPA)*. Fernando is a wedding photographer who does business in historical uptown Whittier area of Southern California. Specializing in wedding photojournalism Fernando has created some of the most powerful and passionate wedding images of today. His work can be seen at www.elegantphotographer.com/.

Becker. Becker, who goes by only his last name, is a gregarious, likeable wedding photojournalist who operates a hugely successful studio in Mission Viejo, CA. He has been a featured speaker at WPPI and has also competed and done well in international print competition.

David Beckstead. David Beckstead lives in a small town in Arizona. With help from the Internet, forums, digital cameras, seminars, WPPI, Pictage and his artistic background, his passion has grown into a national and international wedding photography business. He refers to his style of wedding photography as "artistic photojournalism."

Marcus Bell. Marcus Bell's creative vision, fluid natural style and sensitivity have made him one of Australia's most revered photographers. It's this talent combined with his natural ability to make people feel at ease in front of the lens that attracts so many of his clients. Marcus' work has been published in numerous magazines in Australia and overseas including *Black White, Capture, Portfolio Bride,* and countless other bridal magazines.

Don Blair. For fifty years, the name Don Blair was synonymous with fine portraiture, craftsmanship and extraordinary contributions to the industry. It's no accident that he is among the most respected of all portrait photographers. Don was affectionately known to many as "Big Daddy."

Stacy Dail Bratton. Stacy is a studio owner and an accomplished children's and family photographer, having shot more than 2500 baby portraits over the years. She is a graduate of Art Center College of Design in Pasadena, CA.

Joe Buissink. Joe Buissink is an internationally recognized wedding photographer from Beverly Hills, CA. Almost every potential bride who picks up a bridal magazine will have seen Joe Buissink's photography. He has photographed numerous celebrity weddings, including Christina Aguilera's 2005 wedding, and is a multiple Grand Award winner in WPPI print competition.

Drake Busath *(Master Photographer, Craftsman)*. Drake Busath is a second-generation professional photographer who has spoken all over the world and has been featured in a wide variety of professional magazines. Drake also runs a popular photography workshop series in Northern Italy.

Mark Cafiero. Mark graduated from the University of Northern Colorado with a degree in Business Administration with special emphasis in Marketing. He is the owner of several photography businesses, including Pro Photo Alliance, an online proofing solution

for labs and professional photographers, and his own private wedding, event, and portrait business.

Anthony Cava *(BA, MPA, APPO).* Anthony owns and operates Photolux Studio with his brother, Frank. At thirty years old, he became the youngest Master of Photographic Arts in Canada. Anthony also won WPPI's Grand Award with the first print he ever entered in competition.

Mike Colón. Mike is a wedding photojournalist from the San Diego area. Colón's natural and fun approach frees his subjects to be themselves, revealing their true personality and emotion. His images combine inner beauty, joy, life, and love frozen in time forever. He has spoken before national audiences on the art of wedding photography.

Cherie Steinberg Coté. Cherie Steinberg Coté began her photography career as a photojournalist at the *Toronto Sun,* where she had the distinction of being the first female freelance photographer. She currently lives in Los Angeles and has recently been published in the *L.A. Times, Los Angeles Magazine,* and *Town & Country.*

Dan Doke. Daniel has a drive for perfection, abundant creativity, and special eye for light and form. He is a modern photographer with traditional skills, who draws on his experience in commercial, fashion, and portrait photography to create memorable wedding images.

Mauricio Donelli. Mauricio Donelli is a world-famous wedding photographer from Miami, FL. His work is a combination of styles, consisting of traditional photojournalism with a twist of fashion and art. His weddings are photographed in what he calls, "real time." His photographs have been published in *Vogue, Town & Country,* and many national and international magazines. He has photographed weddings around the world.

Bruce Dorn and **Maura Dutra.** These award-winning digital imagemakers learned their craft in Hollywood, New York, and Paris. Maura has twenty years' experience as an art director and visual effects producer, and Bruce capped a youthful career in fashion and advertising photography with a twenty-year tenure in the very exclusive Director's Guild of America. They have earned a plethora of industry awards for excellence in image-making, and now teach worldwide.

Fuzzy and Shirley Duenkel. Fuzzy has been honored with numerous awards, including four Fuji Masterpiece Awards. In 1996 and 1997, he was named Photographer of the Year for the Southeastern Wisconsin PPA. Fuzzy has had fifteen prints selected for National Traveling Loan Collection, two for Disney's Epcot Center, one for Photokina in Germany, and one for the International Hall of Fame and Museum.

Don Emmerich *(M.Photog., M.Artist, M.EI, Cr., CEI, CPPS).* Don Emmerich belongs to a select group of professionals who have earned all four photographic degrees, and was chosen to be a member of the exclusive Camera Craftsmen of America, a society that is comprised of the top forty portrait photographers in the United States. Don has been PPA's technical editor for more than a decade, with some 150 articles published in various magazines.

Gary Fagan. Gary, with his wife Jan, owns and operates an in-home studio in Dubuque, IA. Gary concentrates primarily on families and high-school seniors, using his half-acre outdoor studio as the main setting. In 2001, he was awarded WPPI's Accolade of Lifetime Excellence.

Brett Florens. Having started his career as a photojournalist, Brett Florens has become a renowned international wedding photographer, traveling from his home in South Africa to Europe, Australia, and the U.S. for the discerning bridal couple requiring the ultimate in professionalism and creativity. His exceptional albums are fast making him the "must have" photographer around the globe.

Greg Gibson. Greg is a two-time Pulitzer Prize winner whose assignments have included three Presidential campaigns, daily coverage of the White House, the Gulf War, Super Bowls, and much more. Despite numerous offers to return to journalism, Greg finds shooting weddings the perfect genre to continually test his skills.

Al Gordon. Al operates a full-service studio and has photographed weddings throughout the Southeast. In addition to holding numerous degrees from PPA and WPPI, he received the coveted Kodak Trylon Gallery Award twice and has images in the coveted ASP Masters Loan Collection.

Judy Host. Judy Host has won numerous awards for her photography and been featured in a number of publications for her outstanding environmental portraiture. The PPA from whom she has received a Masters and a Craftsman degree has selected her work for National Exhibition. She has also received three Kodak Gallery Awards. Many of her images have been exhibited at Epcot Center and are part of a traveling loan collection.

Elaine Hughes. With husband Robert, Elaine Hughes is half of Robert Hughes Photography. She has only been photographing professionally for a few years but has already achieved national notoriety. In her first ever print competition, Elaine scored the third highest print case in the WPPI 2001 print competition and one of her images, *They Didn't Think I Would Make It,* was awarded second place in the photojournalism category.

Tibor Imely. Owned and operated by Tibor Imely, Imely Photography is known as one of the most prestigious studios in the Tampa Bay area. Tibor has won numerous prestigious awards, including the Accolade of Photographic Mastery and Accolade of Outstanding Achievement from WPPI.

Kevin Jairaj. Kevin is a fashion photographer turned wedding and portrait photographer whose creative eye has earned him a stellar reputation in the Dallas/Fort Worth, TX area. His web site is: www.kjimages.com.

Craig Kienast. Working in the small-market town of Clear Lake, IA, Kienast ordinarily gets more than double the fees of his nearest competitor (about $1200 for most of his high-school senior orders). Samples of Craig's work and teaching materials can be seen at www.photock.com.

Scott Robert Lim. Scott is an Los Angeles photographer and educator with a compelling style that blends both photojournalism and portraiture with a modern flare. He is a preferred photographer at many world-renowned establishments, such as the Hotel Bel-Air.

Kersti Malvre. Kersti is well known for her unique style of portraiture that merges black & white with oil painting. She holds the PPA Photographic Craftsman's degree for outstanding contributions to the portrait profession.

Charles and Jennifer Maring. Charles and Jennifer Maring own Maring Photography Inc. in Wallingford, CT. His parents, also photographers, operate Rlab (resolutionlab.com), a digital lab that does all of the work for Maring Photography and other discriminating photographers. Charles Maring was the winner of WPPI's Album of the Year Award in 2001.

Heidi Mauracher *(M. Photog., Cr. CPP, FBIPP, AOPA, AEPA).* The late Heidi Mauracher presented programs before audiences around the world. Her articles and photographic images have been featured in a variety of professional magazines and books, and her unique style won her many PPA Loan Collection prints and more than one photograph that has scored a perfect "100" in international competition. She left us in March, 2003.

Cliff Mautner. Cliff Mautner began his career as a photojournalist and never dreamed that he would be enjoying wedding photography as much as he does. His images have been featured in *Modern Bride, Elegant Wedding, The Knot,* and numerous other publications.

Mercury Megaloudis. Mercury Megaloudis is an award-winning Australian photographer and owner of Megagraphics Photography in Strathmore, Victoria, Australia. The AIPP awarded him the Master of Photography degree in 1999. He has won awards all over Australia and has begun entering and winning print competition in the U.S.

Tom Muñoz. Tom Muñoz is a fourth-generation photographer whose studio from Fort Lauderdale, FL. Tom upholds the classic family traditions of posing, lighting, and composition, yet is 100-percent digital. He believes that the traditional techniques blend perfectly with exceptional quality of digital imaging.

Ferdinand Neubauer (*PPA Certified, M.Photog.Cr., APM*). Ferdinand Neubauer started photographing weddings and portraits over thirty years ago. He has won many awards for photography on state, regional, and international levels. He is also the author of *The Art of Wedding Photography* and *Adventures in Infrared* (both self-published). His work has appeared in numerous publications and he has been a speaker at various photographic conventions and events.

Mark Nixon. Mark, who runs The Portrait Studio in Clontarf, Ireland, recently won Ireland's most prestigious photographic award with a panel of four wedding images. He is currently expanding his business to be international in nature and he is on the worldwide lecture circuit.

Dennis Orchard. Dennis Orchard is an award-winning photographer from Great Britain. He is a member of the British Guild of portrait and wedding photographers, and has been a speaker and an award-winner at numerous WPPI conventions. His unique wedding photography has earned him many awards, including WPPI's Accolade of Lifetime Photographic Excellence.

Parker Pfister. Parker Pfister, who shoots weddings locally in Hillsboro, OH, as well as in neighboring states, is quickly developing a national celebrity. He is passionate about what he does and can't imagine doing anything else (although he also has a beautiful portfolio of fine-art nature images). Visit him at www.pfisterphoto-art.com.

Joe Photo. Joe Photo's wedding images have been featured in numerous publications such as *Grace Ormonde's Wedding Style, Elegant Bride, Wedding Dresses,* and *Modern Bride.* His weddings have also been seen on NBC's *Life Moments* and Lifetime's *Weddings of a Lifetime* and *My Best Friend's Wedding.*

JB and DeEtte Sallee. Sallee Photography has only been in business since 2003, but it has already earned many accomplishments. In 2004, JB received the first Hy Sheanin Memorial Scholarship through WPPI. In 2005, JB and DeEtte were also named Dallas Photographer of The Year.

Marc Weisberg. Marc Weisberg specializes in wedding and event photography. A graduate of UC Irvine with a degree in fine art and photography, he also attended the School of Visual Arts in New York City before relocating to Southern California in 1991. His images have been featured in *Wines and Spirits, Riviera, Orange Coast Magazine,* and *Where Los Angeles.*

David Anthony Williams (*M.Photog. FRPS*). Williams operates a wedding studio in Ashburton, Victoria, Australia. In 1992, he was awarded Associateship and Fellowship of the Royal Photographic Society of Great Britain (FRPS). In 2000, he was awarded the Accolade of Outstanding Photographic Achievement from WPPI. He was also a Grand Award winner at their annual conventions in both 1997 and 2000.

Jeffrey and Julia Woods. Jeffrey and Julia Woods are award-winning wedding and portrait photographers who work as a team. They were awarded WPPI's Best Wedding Album of the Year for 2002 and 2003, two Fuji Masterpiece awards, and a Kodak Gallery Award. See more of their images at www.jwweddinglife.com.

Reed Young. Reed is a graduate of Brooks Institute who has focused his interests on fashion photography. Although he grew up in Minnesota, he is currently working out of New York. More of his work can be seen at www.reedyoung.com.

Yervant Zanazanian (*M. Photog. AIPP, F.AIPP*). Yervant was born in Ethiopia (East Africa), where he worked after school at his father's photography business (his father was photographer to the Emperor Hailé Silassé of Ethiopia). Yervant owns one of the most prestigious photography studios of Australia and services clients both nationally and internationally.

OTHER BOOKS FROM
Amherst Media®

THE BEST OF
PORTRAIT PHOTOGRAPHY
2nd Ed.

Bill Hurter

View outstanding images from top pros and learn how they create their masterful classic and contemporary portraits. $34.95 list, 8.5x11, 128p, 180 color photos, index, order no. 1854.

THE BEST OF
PHOTOGRAPHIC LIGHTING
2nd Ed.

Bill Hurter

Top pros reveal the secrets behind their studio, location, and outdoor lighting strategies. Packed with tips for portraits, still lifes, and more. $34.95 list, 8.5x11, 128p, 200 color photos, index, order no. 1849.

PROFESSIONAL
PORTRAIT LIGHTING
TECHNIQUES AND IMAGES FROM MASTER PHOTOGRAPHERS

Michelle Perkins

Get a behind-the-scenes look at the lighting techniques employed by the world's top portrait photographers. $34.95 list, 8.5x11, 128p, 200 color photos, index, order no. 2000.

SOFTBOX LIGHTING
TECHNIQUES
FOR PROFESSIONAL PHOTOGRAPHERS

Stephen A. Dantzig

Learn to use one of photography's most popular lighting devices to produce soft and flawless effects for portraits, product shots, and more. $34.95 list, 8.5x11, 128p, 260 color images, index, order no. 1839.

JEFF SMITH'S LIGHTING FOR
OUTDOOR AND LOCATION
PORTRAIT PHOTOGRAPHY

Learn how to use light throughout the day—indoors and out—and make location portraits a highly profitable venture for your studio. $34.95 list, 8.5x11, 128p, 170 color images, index, order no. 1841.

MONTE ZUCKER'S
PORTRAIT PHOTOGRAPHY
HANDBOOK

Acclaimed portrait photographer Monte Zucker takes you behind the scenes and shows you how to create a "Monte Portrait." Covers techniques for both studio and location shoots. $34.95 list, 8.5x11, 128p, 200 color photos, index, order no. 1846.

ILLUSTRATED DICTIONARY
OF PHOTOGRAPHY

Barbara A. Lynch-Johnt & Michelle Perkins

Gain insight into camera and lighting equipment, accessories, technological advances, film and historic processes, famous photographers, artistic movements, and more with the concise descriptions in this illustrated book. $34.95 list, 8.5x11, 144p, 150 color images, index, order no. 1857.

MORE PHOTO BOOKS ARE AVAILABLE

Amherst Media®
PO BOX 586
BUFFALO, NY 14226 USA

INDIVIDUALS: If possible, purchase books from an Amherst Media retailer. Contact us for the dealer nearest you, or visit our web site and use our dealer locater. To order direct, visit our web site, or send a check/money order with a note listing the books you want and your shipping address. All major credit cards are also accepted. For domestic and international shipping rates, please visit our web site or contact us at the numbers listed below. New York state residents add 8.75% sales tax.

DEALERS, DISTRIBUTORS & COLLEGES: Write, call, or fax to place orders. For price information, contact Amherst Media or an Amherst Media sales representative. Net 30 days.

(800)622-3278 or (716)874-4450
FAX: (716)874-4508

*All prices, publication dates, and specifications
are subject to change without notice.
Prices are in U.S. dollars. Payment in U.S. funds only.*

WWW.AMHERSTMEDIA.COM
FOR A COMPLETE CATALOG OF BOOKS AND ADDITIONAL INFORMATION